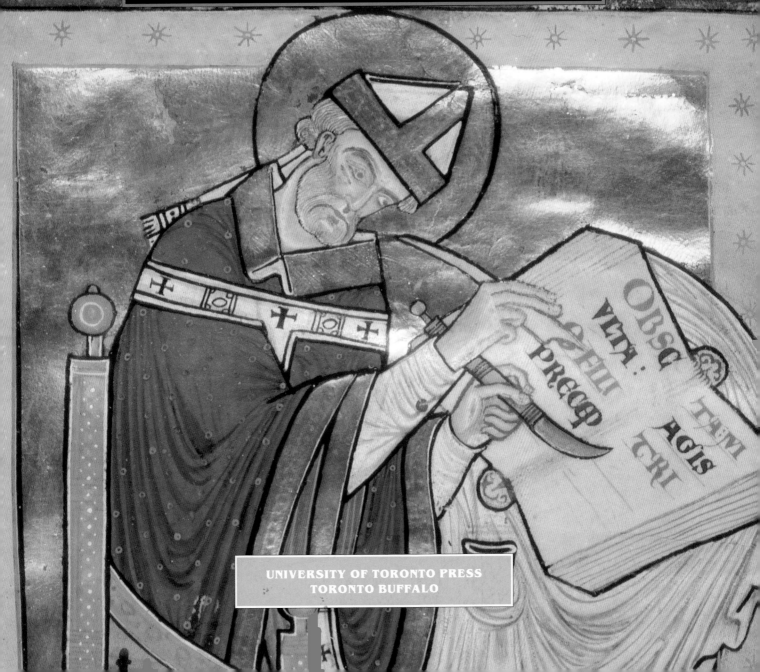

MEDIEVAL CRAFTSMEN

SCRIBES AND ILLUMINATORS

CHRISTOPHER DE HAMEL

UNIVERSITY OF TORONTO PRESS
TORONTO BUFFALO

© 1992 Trustees of the
British Museum
First published in
North America 1992 by
University of Toronto Press
Toronto, Buffalo
Reprinted 1994, 1997, 1999, 2002,
2004

**Canadian Cataloguing in
Publication Data**

De Hamel, Christopher, 1950–
 Scribes and illuminators

(Medieval craftsmen)
Co-published by the British
Museum.
Includes bibliographical
references and index.

ISBN 0-8020-7707-2

1. manuscripts, Medieval.
2. Illumination of books and
manuscripts, Medieval.
3. Books – History – 400–
1400. 4. Books – History –
1400–1600. 5. Book industries
and trade – History.
I. British Museum. II. Title.
III. Series.

26.045 1992 686'.09'02
092-093524-9

Designed by Roger Davies
Set in Palatino
by SPAN, Lingfield, Surrey
Manufactured in China

Front cover Jean Miélot was
scribe and translator to the
Dukes of Burgundy. He is
shown here in a manuscript
which he copied out himself
around 1450 for the library of
Philip the Good, Duke of
Burgundy 1419–67.

Back cover A richly illuminated
Book of Hours. See also
Fig. 39.

Title page St Dunstan,
archbishop of Canterbury,
shown copying a manuscript
of the Rule of St Benedict.
This is the frontispiece to a
commentary on the Rule,
illuminated for the Cathedral
Priory of Christ Church,
Canterbury, about 1170.
Although Dunstan is seen
here writing big coloured
initials, he is nevertheless
using a pen, not a brush, and
he is holding down his
parchment with a curved
penknife.

This page In this dedication
scene in a mid-twelfth-century
Lectionary, probably painted
in Salzburg, an abbot is shown
offering the manuscript itself
to a patron saint. The book is
depicted as being in a jewelled
binding over thick wooden
boards.

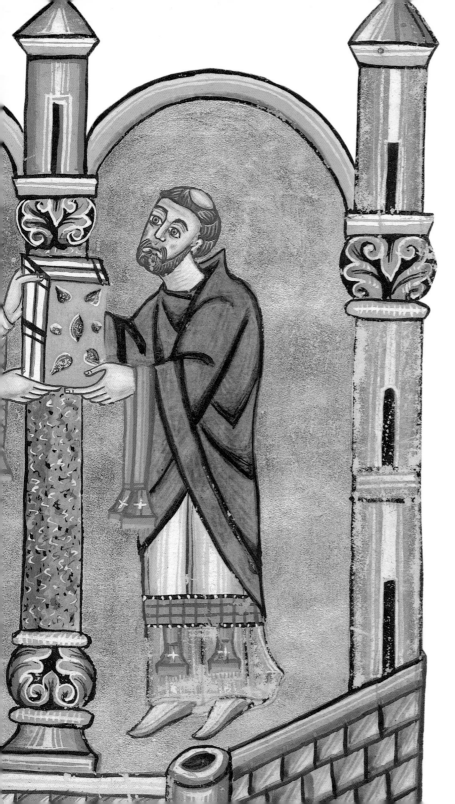

Contents

INTRODUCTION

More manuscripts survive from the Middle Ages than any other artefacts. Original manuscripts can be seen in public and university libraries, in cathedrals and museums, and in private collections and bookshops. One can still turn the pages of medieval manuscripts, admiring the handwritten script and feeling the slightly furry texture of the parchment pages. One can look at the decoration, watching the light sparkling off the burnished gold and noticing animals and birds half-hidden in the formal tangle of leaves and flowers. One can gaze at the pictures and look straight into the eyes of an evangelist painted twelve hundred years ago or at the fairytale Gothic landscapes of the fifteenth century. One can close the book, and feel its weight, and examine the massive wooden binding. Then, if you have found a patient curator or rare books librarian, ask for another manuscript, and another, and start to notice the differences in the books brought out. Some will be vast and may need to be trundled out on a trolley, some will be small enough to fit into the palm of the hand, some will be written on what seems to be paper (it is, in fact, exactly that), and some will seem disappointing because they appear to have almost no decoration at all.

The questions asked by those being shown medieval manuscripts for the first time will usually be: is it true that all these books were made by monks? How long did the books take to make? How did they make them? It is absolutely impossible to approach such questions without making completely clear from the outset that medieval manuscripts were being made at all times during a period of about fifteen hundred years, between the late Roman Empire and the high Renaissance, in every part of Europe and in conditions as varied as it is possible to imagine from hermits' cells in the mountains to sophisticated commercial production lines in the big cities. No specific statement about the production of a medieval manuscript can be applied to every medieval manuscript;

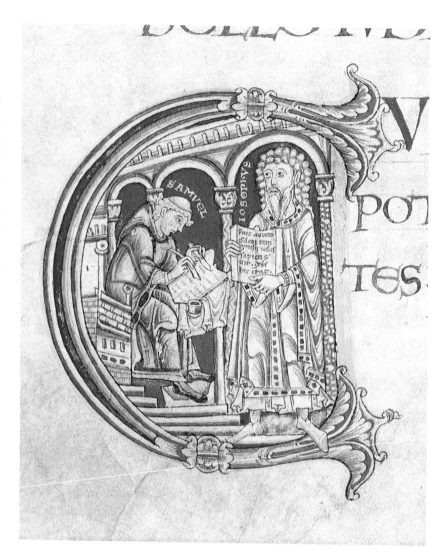

1 The author Josephus standing holding a manuscript which is being copied out by his scribe Samuel, a first-century scene here envisaged by an illuminator working in Canterbury c.1130. The scribe is shown as a monk in a Romanesque cloister, writing into an open book.

the field is simply too vast to generalise. Nor is it easy to know where to begin or end the investigation. Every proposition raises another question about where or why some particular feature began or how it came to be there. Every conclusion is incomplete without asking what happened next.

Over such a vast period, style cannot be discussed at all. The history of handwriting and of pictorial art is extraordinarily interesting, as one stream mingles with another and branches off again in infinitely complex relationships. Each scribe or illuminator will write or paint in the style of his time. One simply cannot go further than this without losing all thread of the narrative. Nor, in the end, can we necessarily answer many questions about the techniques used by the craftsmen. Any statements must be based on what one can see by scrutinising surviving illuminated manuscripts, by sifting historical records, by studying the instructions of contemporary craftsmen, and by practical experiment in trying to recreate the process. It is a delicate balance. Sometimes there are no answers at all.

But let us take the three questions in order. Is it true that all these books were made by monks? The short answer is no. The long answer is less dogmatic. As Christianity advanced across pagan Europe in the Dark Ages, it brought with it the Mediterranean skills of reading and writing. The Rule of St Benedict encouraged monks and nuns in the use of books, and monasteries and religious communities needed libraries. Teaching children to read was one of the parochial duties of the Church, and perhaps most literate people in the Middle Ages had received some or all of their education from the Church. Until the eleventh or twelfth century, probably most manuscripts were indeed made in monasteries. Monks sat in the cloisters copying and studying texts, and devoted leisure and skill to doing so. There was not much private ownership of books a thousand years ago, and most religious communities simply produced manuscripts for their own use and for that of their dependents. Only a finite number of texts had ever been written, and theoretically a monastery could hope to be fairly comprehen-sive in its collection of several hundred manu-scripts.

By about 1100, however, the number of new texts was increasing and monastic libraries found it more and more difficult to keep their collections up to date, and they began employ-ing secular scribes and illuminators to col-laborate in book production. In the twelfth century, the early universities of Paris and Bologna introduced education which was more-or-less independent of the monasteries, and, as the number of authors writing books rose increasingly with every decade, it became impossible for many monastic librarians to keep up with new books. It became more and more common for people to want to own books themselves, whether students seeking text-books or noble women desiring to own beauti-fully illluminated Psalters. By 1200 there is quite good evidence of secular workshops writing and decorating manuscripts for sale to the laity. By 1250 there were certainly bookshops in the big university and commercial towns, arranging the writing out of new manuscripts and trading in second-hand copies. By 1300 it must have been exceptional for a monastery to make its own manuscripts: usually, monks bought their books from shops like anyone else, although this is not quite true of the Carthusians or of some religious communities in the Netherlands.

If a layman in the fifteenth century wanted to buy a Book of Hours, for example, he would go to a bookshop or stationer and commission one. Such shops were clustered around the cathedrals and market squares of big towns. The customer might be shown second-hand copies but if he wanted a new manuscript he would have to discuss the size and content and the extent of decoration and the price of the book. Then a time was probably agreed on, and the bookseller set to work writing the book or, more likely, subcontracting the work to professional scribes and then to professional illuminators. Sometimes the scribes seem to have lived with the stationers, or at least to have worked directly for them in the shop. Illuminators, however, doubtless mostly worked at home among their families and apprentices in a cheaper area of town. They were paid craftsmen,

2 A Book of Hours illuminated in London in a professional workshop in the late fourteenth century.

like any others, and often members of guilds. They were by no means anonymous monks and we know the names and addresses of very many late medieval miniaturists and illuminators.

Thus, to summarise so far, until about 1100 most books were indeed made by monks, and after about 1200 most books were probably not made by monks and the actual techniques used to make the books were not necessarily any different whether executed in a rural cloister or an urban attic studio. In the chapters which follow, some distinctions are made between the monastic period – which is generally earlier – and the secular period of the later Middle Ages. It is not a neat separation, and the dividing line is not always clear.

The second question, then, is how long manuscripts took to make. It depends on the length of the book, and who was making it. A monk had other commitments as well as book production, and not only attended chapel up to eight times a day but also took turns in other tasks around the monastery's school, kitchen, guest house or garden. There is evidence of monastic manuscript-making projects extending over years, and doubtless it was often very much a part-time occupation. An eleventh-century monastic scribe, in no great haste, might achieve three or four moderate-sized books a year. A professional scribe, however, working for a commercial bookshop in the fifteenth century, was paid by the job and not by the hour. There are manuscripts in which the scribe announces at the end that the work was started and finished in a matter of days. The Renaissance scribe Giovanni Marco Cinico, who mostly worked in Naples 1458–98, boasted that he wrote full-length manuscripts in fifty-two or fifty-three hours, and he was nicknamed *Velox*, speedy. Perhaps a Book of Hours might usually be written out within a week, and the miniatures might well be executed at the rate of two or three a day. A professional artisan who knows his job and repeats it throughout a lifetime can often work extremely fast.

The chapters which follow make the process seem immensely slow as one stage is discussed after another. In practice, of course, many tasks took place simultaneously. The parchmenter is scraping last week's skins while this week's supply is soaking in vats in the shed. Fresh quills are drying out while the scribe is writing with earlier stock. The illuminator during a lunch break checks on the infusions of next week's pigments in the pantry. Certain devices for speeding the process further were evolved during the centuries, culminating at last in the invention of printing around 1450. The really very considerable production achievement of medieval manuscripts in the centuries until then is the best possible evidence of a successful craft.

The third question, then, was how did they make them? Subject to all the caution of paragraph two above, read on.

1 PAPER- AND PARCHMENT-MAKERS

Parchment is made from the skin of an animal. The process of transforming the animal skin into a clean white material suitable for writing medieval manuscripts was the task of the *percamenarius*, the 'parchment-maker' or parchmenter. Such professionals existed throughout the Gothic period and probably back into the Romanesque and Carolingian ages. Thus, in the year 822, Abbot Adelard instituted a parchment-maker among the officers of his Abbey of Corbie in northern France and there was a lay *percamenarius* in Regensburg in the early twelfth century. The earliest documentary evidence of book production in Oxford is a land charter dating from not long after 1200, witnessed by a scribe, three illuminators and two parchment-makers whose names are Reginald and Roger. In thirteenth-century Florence, parchment-makers had a shop beside the Badia. In Ghent in 1280 there were town statutes mentioning parchment-makers. The Paris tax rolls of 1292 include names of nineteen parchment-makers and the list is not complete. In the late Middle Ages parchment-makers took their place among the artisans and tradesmen of every town.

In normal usage, the terms 'parchment' and 'vellum' are interchangeable, 'That stouffe that we wrytte upon: and is made of beestis skynnes: is somtyme called parchment somtyme velem', wrote William Horman in the early sixteenth century. In the manuscripts department of the Bodleian Library in Oxford the house usage today is to refer to the material consistently as parchment; in the British Library in London, the same substance is standardly called vellum. The material is the same. The word parchment, usually *pergamenum* in medieval Latin, derives from the name of the city of Pergamum whose ancient King Eumenes II is said by Pliny to have invented it in the second century BC during a trade blockade on papyrus. The word vellum has the same origin as veal or *veau* in French, in other words, calf, *vitellus* in Latin, and is strictly the writing material made from cow skin. But except with magnification and a good knowledge of dermatology it is practically impossible to tell the prepared skin of one animal from another, and doubtless most medieval scribes and readers of manuscripts neither knew nor cared what the animal had been when alive. 'Is not parchment made of sheep-skins?', asks Hamlet in the graveyard (Act 5, scene 1, line 110); 'Ay, my lord', Horatio replies, 'and of calves' skins too'. Goatskin was often used in Italy, as one might expect, and probably there are more manuscripts than we would expect written on deer or pigskin, or even hare and squirrel.

The preparation of parchment is a slow and complicated process. It will take some detail (as indeed it does in medieval recipes) to describe the stages of its manufacture. Early craftsmen's manuals emphasise that the selection of good skins is crucial. More so than in today's scientifically controlled agriculture, medieval farm animals probably suffered from diseases and ticks, and these can leave unacceptable flaws on the skin of the flayed animal. A parchmenter, looking over available skins in the abattoir, would probably also have to consider the colour of the wool or hair as this will be reflected on the final surface of the parchment: white sheep or cows will tend to produce white parchment, and the shadowy brown patterns which are one of the aesthetically pleasing features of parchment may often be echoes of brindled cows or piebald goats.

First of all the parchmenter has to wash a skin in cold clear running water for a day and a night (according to one recipe) or simply 'til hit be clene ynoughe', according to another. As a skin begins to rot, the hair naturally falls out. In hot countries the damp skins may have been laid out in the sun to allow this to take place. Usually, however, the process of loosening the hair in parchment making is artificially induced by soaking the skins in wooden or stone vats in a

3 A parchment-seller's shop, illustrated in a fifteenth-century Italian chronicle. One man is trimming the sheets into rectangles and the other is rubbing them down with chalk in preparation for writing. The stock for sale on the shelves includes both rolls and packets of ready-folded sheets.

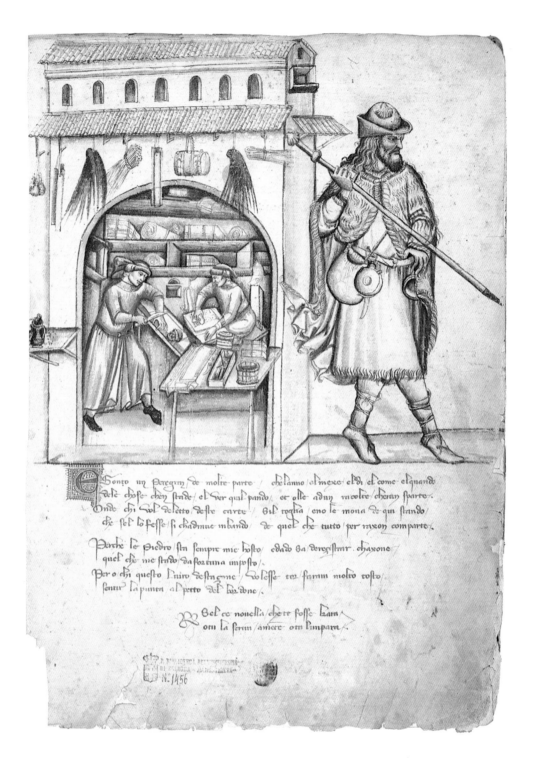

eam in celo psentare ualeat: pmu induumentum uui amma
uestiri debet: est mundicia. Nulla enim incelesti curia psentac:
qui ut hic uel insuturio nimundet. alia uero induumenta sunt.
pietas. misedia: ceterq; uirtutes quilx debet uestiri; Via au
talibx induuitis cum tribz conducteis z. cogitacione pura.
uibo bono. ope pferto. in celesti gla honeste potest psentari
ü remunerabitur illa beatitudine. qm optinent angli ad
quam optinendam hominem ds creauit. z tres consilia
tres ei attribuit scilicet spualem intellectum. potestatem
bñ agendi: z sapientiam quibz si acquiesceret. regnum ce
leste non amittet. s; quia ist non adquieuit hereditate
suam amisit;

O uis molle pecus lanis
corpore inerme. ani
mo placidum. ab ob
lacione dictum. eo
quod apud ueteres
nutio in tauri. s; oues
in sacrificio macta
rentur; Ex his qual
dam bidentes uocat.
easq; inf octo dentes
duos altiores hñt. qs
maxime gentiles in sacrificium offerebant; Ouis
sub aduentu hyemis inexplebilis ad escam. insacia
biliter herbam rapit. eo quod psentiat asperitatem
hyemis ad futuram. ut se prius herbe pabulo satu
at. quam gelu adurente omnis herba deficiat;

4 A sheep, depicted in a
twelfth-century English
Bestiary, or book of animals.
Sheepskin was one of the
most common sources of
medieval parchment.

solution of lime and water for between about three to ten days (longer in winter, apparently, and better too long than too short), stirring the vats several times a day with a wooden pole.

One by one, the wet slippery skins are scooped out and draped hairside out over a great curved upright shield of wood, called a beam. The parchment-maker stands behind the beam, leaning forward over the top, and scrapes away the hair with a long curved knife with a wooden handle at each end. The hair falls away surprisingly fast, slipping down into a soggy pile at the foot. The bare skin is revealed underneath, looking pink where the animal's hair was white and paler where it was brown. Where possible the outer film is scraped away too. This surface where the hair has been is known as the grain side of the parchment. The skin is still very wet and dripping with the lime solution. It may sometimes be re-immersed in the vat after the hair has been peeled away. In either case it is then flipped over on the wooden

5 A modern parchment-maker stretching the wet skin across a wooden frame and attaching its edges with adjustable pegs.

beam so that the original inner side is outermost and the parchmenter once again leans over the board with the curved knife and pares away the residue of clinging flesh. If pushed too hard it can cut through the skin by mistake, and this energetic fast scraping requires a surprising delicacy of touch and experience. The de-haired and tidied-up pelt is then once more rinsed for two further days in fresh water to clear it of the lime. This completes the first and smelliest stage of parchment-making.

In the second phase of the process the skin is actually made into parchment. It centres around the drying of the skin while it is stretched taut on a frame. The pelt, floppy and wet from its last rinse, is suspended spread-eagled in a wooden frame. This frame can be hoop-shaped (medieval 5 instructions describe it as *circulus*) or more-or-less rectangular like the frame of a blackboard and about as big, as shown in a twelfth-century manuscript from Bamberg. The skin cannot be nailed to the frame because as it dries it shrinks and the edges would tear away (and in any case the frames are used over and over again and would become unserviceable if riddled with nail holes) and so instead the parchmenter suspends the skin by little strings attached to adjustable pegs in the frame. Every few centimetres around the edge of the skin the parchment-maker pushes little pebbles or smooth stones into the soft border, folding them in to form knobs which are then looped around and secured with cord. The other end of the cord is then anchored into the slot of a revolving peg in the frame. One by one these knobs and strings are lashed around the edge until the whole skin resembles a vertical trampoline, and the pegs are turned to pull the skin taught. As it stretches so any tiny gashes or cuts accidentally made in the flaying or de-hairing will be pulled out into circular or oval holes. It is not uncommon to see such holes in pages or margins of medieval manuscripts. If the parchmenter notices cuts in time they can be stitched up with thread to stop their expansion into holes; sometimes in pages of manuscripts one sees holes with stitch marks around their 6 edges, evidently indicating that cuts were mended but nevertheless split their sewing and opened up again under pressure.

6 Original holes in parchment pages of manuscripts seem to occur especially often in monastic manuscripts, since many monks could not afford (or did not care for) the luxury of rejecting sheets accidentally damaged in preparation. The scribe here has carefully written his text around a hole in a late twelfth-century manuscript made probably at Winchcombe Abbey in Gloucestershire.

7 This is a twelfth-century German drawing of a monk preparing parchment which is stretched and pegged into a rectangular frame and then scraped with a curved knife, or *lunellum*, on a handle.

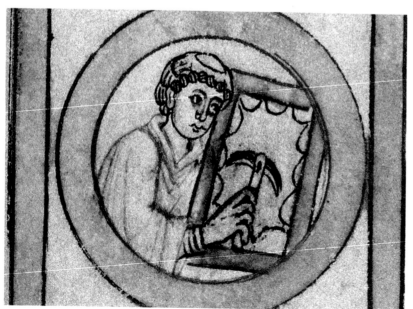

The skin is now tight and rubbery but still wet. The parchment-maker keeps it wet initially by ladling on scoops of hot water which run down the skin and puddle onto the ground. He then stands firmly, perhaps with one leg securely through the edge of the wooden frame, and begins scraping vigorously at the skin using a curved knife with a central handle. An ordinary knife would have a sharp corner and so could too easily cut the tight surface. The crescent-shaped knife was called a *lunellum* and occurs in medieval pictures of parchment-makers as their most recognisable tool, and is used to give both surfaces a really thorough scraping, especially the flesh side of the skin. As the work progresses the parchmenter is constantly tightening the pegs and tapping them with a hammer to keep them fixed. Then the taught skin is allowed to dry on the frame, perhaps helped by exposing it to the sun as this stage is most effective if it happens fast, and it shrinks and becomes tighter still as it does so.

When it is all dry, the scraping and shaving begins again. The skin is now as tight as a new drum and the noise in the workshop of the metal knife on the surface is considerable. Fluffy little peelings fall away as layer after layer are pared off. Probably in the Middle Ages these shavings were swept up and saved to use later for boiling up to make glue. The amount of scraping will depend on the fineness of the parchment being made. In the early monastic period of manuscript production parchment was often quite thick, but by the thirteenth century it was being planed away to an almost tissue thinness. The grain side where the hair had once been has to be scraped away especially at this final stage to remove the glassy shine unsatisfactory as a writing surface.

Now the pegs can be undone. The dry thin opaque parchment is released and can be rolled up and stored or taken to be sold. Probably when medieval scribes or booksellers bought vellum from a *percamenarius* it was like this, not yet buffed up and rubbed with chalk in preparation for the actual writing. Prices of parchment of course varied greatly, but sheets were mostly sold by the dozen. The accounts of the Sainte-Chapelle in Paris include the expenses in 1298 of

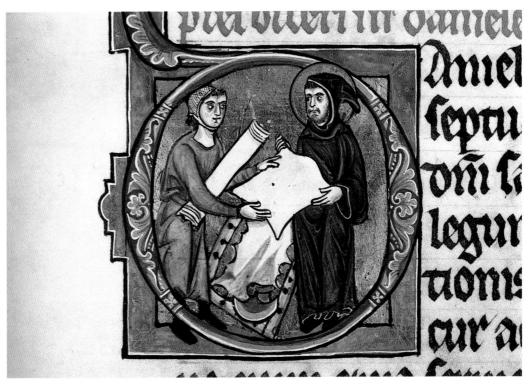

8 A monk inspecting a sheet of parchment which he is buying from a parchment-maker, as shown in an initial in a thirteenth-century German manuscript. In the background is the craftsman's curved paring-knife and a skin stretched over its wooden frame.

the huge quantity of 972 dozen skins at the cost of 194 *livres* and 18 *sous* (this works out at 3 *sous* a skin, a considerable sum), plus 24 *livres* and 6 *sous* for scraping them, and 60 *sous* to one Harvey for selecting the skins (that is, half a per cent) and 10 *sous* to the valuer. There are English references to parchment-makers charging $1\frac{1}{4}$d. per skin in 1301, 8s.8d. for six dozen leaves in 1312–13, 6s. for two dozen leaves in 1358–59 (both the latter can be divided out to just 3d. a sheet), but as much as £4.6s.8d. for the thirteen dozen skins of best calf (*percamenti vitulini*) for the luxurious Litlyngton Missal for Westminster Abbey in 1383–4. This then cost just over $6\frac{1}{2}$d. a sheet, and was the second largest expense after the gold in making the book. It was evidently top quality parchment for a book intended to be a monument forever.

Parchment is extraordinarily durable, far more so than leather, for instance. It can last for a thousand years, or more, in perfect condition. Good parchment is soft and thin and velvety,

and folds easily. It can be fascinating to turn a few pages of a medieval manuscript peering through a magnifying glass at the parchment. No facsimile can ever give the tactile experience of handling and running one's fingers across soft leaves of medieval parchment. Even the smell is quite different from that of paper, and in fact varies enormously with manuscripts from one country to another. Within moderation, a bit of handling is said to be good for manuscripts because parchment, like leather, responds well to movement and can lose suppleness if untouched for centuries.

The grain side of the sheet, where the hair once was, is usually darker in colour, creamy or yellower (especially with sheep parchment) or brownish grey with goat parchment. The grain side, too, tends to curl in on itself. In some poorer quality scholastic manuscripts, made of cheap parchment, this curling tendency is so marked that the pages can almost roll up before one's eyes. This is because when it was on the

9 The Litlyngton Missal is still in Westminster Abbey for which it was made in 1383–4 at the expense of Nicholas Litlyngton, Abbot of Westminster from 1362 to 1386. The detailed accounts survive for the cost of making the book. The scribe was Thomas Preston who was employed for two years and paid £4, plus expenses. The small miniatures, like that here showing St Edward the Confessor, founder of Westminster Abbey, cost approximately 7s.6d. each.

animal the outer side was less elastic and, after being released from the tension of the parchmenter's frame, it tends to contract rather more than the original flesh side. The better the vellum, the more suede-like the grain surface feels because its outer layer has had to be pared right away and we are experiencing the furry inside texture of the skin. Especially in Italian manuscripts, the ink tends not to adhere so well to this side and it looks a dusty brown. Through a magnifying glass one can sometimes (not always) see constellations of tiny dots which were once hair follicles.

Turn the skin over to the flesh side and you will see this is whiter than the grain side and usually smoother and tends to be convex, naturally curling away. If one is permitted to fan out the edges of half a dozen or so adjacent pages of a medieval parchment manuscript, this difference of colour becomes very striking: yellow/white/yellow/white/yellow and so on.

The implications of this will be considered below when we come to the mechanics of folding the parchment sheets into book format. Sometimes too one can see tree-like vein marks on parchment, the result of blood in the skin when the animal died (this ought to be more common in pelts from hunted animals, like deer, than from those killed and bled in a butcher's shop, but it is difficult to know how to set about proving it). If the flaws were too rough and pronounced and yet the scribe decided to use the sheet nonetheless, a ring may have been drawn around the blemish and the scribe's subsequent writing parts like the Red Sea to flow around it. On big pages one can sometimes detect denser ridges where the backbone transected the skin and perhaps on one edge one may observe (aided perhaps by imagination) the scalloped curve which was the neck of the animal.

It is with reluctance that one mentions, albeit

10 Pages of a parchment manuscript sometimes appear noticeably yellow on what was originally the hair-side of the skin and much whiter on what was originally the flesh side.

briefly, the vexed and unresolved question of uterine vellum. Old-fashioned books about medieval manuscripts assert that the finest medieval parchment was made from the skin of aborted calves, and the term is still sometimes used to describe that extremely thin silky parchment used to perfection in tiny thirteenth-century Paris Bibles. There is some medieval evidence that aborted skin was valuable and desirable, and it is true that parchment made from this rather unappealing material or from the skins of very new-born animals does indeed look and feel like that which antiquarians call uterine vellum. But it is very difficult to believe that thousands of cows miscarried for generations, or were deprived of their foetuses in such numbers to supply the booktrade economically. Either normal skins had been pared down and down so that only the tissue-thin membrane remained, or, perhaps more likely, the skins were actually split to produce two sheets out of a single thickness. Again there is some (not much) medieval evidence for this taking place. If the term uterine parchment must be used at all, it should perhaps refer to a quality of skin and not to its origin.

Having described the parchment-maker's work at some length, it ought now to be tempered with the statement that not all medieval manuscripts were written on parchment. The Middle Ages opened with a long legacy of papyrus book production, and this fragile Egyptian reed material lingered on in occasional use until the seventh or even eighth century. Papyrus is inexpensive to make and suitable for writing scrolls but is not satisfactory for texts bound in book form because pages tend to snap off when they are turned repeatedly and the folds are not strong enough to support constant pressure on sewing threads in the centre of the gatherings. The word *papyrus*, however, survives in modern English in our word 'paper'. There are indeed very many medieval manuscripts written on paper. Cheap little books made for clerics and students were probably more often on paper than on parchment by the fifteenth century. Even major aristocratic libraries did not despise manuscripts on paper. The inventory of the library of the Dukes of Burgundy in about 1467 lists just over nine hundred volumes, recording usually whether the books were written on parchment or on paper; 196 manuscripts, just over 20 per cent of the total in the most princely library in northern Europe, were described as written on paper. Two volumes in the ducal collection are described as mixed paper and parchment, 'moictié papier, moictié parchemin'. Some paper manuscripts survive like this with the inner and outer pairs of leaves in each gathering made of parchment, presumably because parchment is (or was assumed to be) stronger and these were the most vulnerable pages.

Paper was a Chinese invention probably of the second century and the technique of paper-making spent a thousand years slowly working its way through the Arab world to the West. By the thirteenth century there were established paper mills in Spain and Italy, and in France by about 1340, Germany by 1390, but probably not in England until the later fifteenth century. Paper was exported from its place of manufacture into all parts of Europe and the first paper manuscripts were administrative records, merchants' accounts, and other more-or-less ephemeral texts. By about 1400 it was becoming a relatively common medium for little volumes of sermons, cheap textbooks, popular tracts, and so on. As late as 1480 a ruling of the University of Cambridge stipulated that only books on parchment could be accepted as security for loans. Paper was evidently thought to be too insignificant. It was the invention of printing in the 1450s which transformed the need for paper, and by the later fifteenth century it had become so infinitely cheaper than parchment that it was being used for all but the most luxurious books, as it still is today.

Medieval paper was made from linen rags. It is much stronger and more durable than modern wood-pulp paper, and fifteenth-century scribes were wrong if they believed that it would not survive. Very briefly, rag paper is manufactured as follows. White rags are sorted and washed thoroughly in a tub pierced with drainage holes and they are then allowed to ferment for four or five days. Then the wet disintegrating pieces are cut into scraps and beaten for some hours in

11 A medieval watermark of the middle of the second half of the fifteenth century, photographed by beta-radiography.

ferred into the thickness of the paper, invisible when the paper was stacked or folded in a book but quite clear when held up to the light. Thus watermarks came into being as a means of distinguishing paper stocks and their makers. Watermarks are one of the most common and most self-effacing classes of medieval pictorial art, but they lie hidden waiting to be detected in the thickness of pages of second-class manuscripts: whole bestiaries of lions, bears, boars, basilisks, unicorns, eagles, swans, lobsters, elephants (two instances have been recorded of elephants, in Italian paper used in Brussels in 1366 and Perpignan in 1380), sheep, oxen, horses, hounds, deer, fish, pascal lambs, angels, suns, stars, moons, mountains, castles, shields, helmets, swords, bows and arrows, axes, crowns, orbs, flags, cardinals' hats, ships, anchors, bellows, scissors, keys, bells, pairs of spectacles (first recorded in an Italian watermark used in Bourges in 1387), flowers, hunting horns, and so forth, thousands of images full of delight and elusiveness.

Before a late medieval scribe could begin to write out a manuscript, a decision had to be made whether to use paper or parchment. Paper was cheaper and lighter and had the advantage of being supplied in sheets of an exact format. Parchment was thought to be stronger and has a slightly springy writing surface which gives an agreeable flexibility to penstrokes as compared with the unyielding flatness of writing on paper. (As a modern parallel, it is easier and more tempting to write calligraphically with a soft felt-tip pen than with a metal-ended ball-point.) The most beautiful and elaborate manuscripts were always on parchment, which was used for Books of Hours and other traditional books intended for a long life.

Parchment or paper as finished by the parchmenter or paper-maker is supplied in large rectangular sheets. Dimensions of a parchment skin are determined by the shape of the original animal and, as animals are oblong (with legs at each end), so the sheets similarly emerge oblong even when their irregular edges have been squared off. (We shall return to this observation later.) A book is not made up of single pages, but of pairs of leaves or bifolia. Several pairs of

clean running water, left to fester for a week, beaten again, and so on, several times over, until the mixture disintegrates into a runny waterlogged pulp. It is then tipped into a huge vat. A wire frame is scooped into the vat, picking up a film of wet fibres, and it is shaken free of drips and emptied onto a sheet of felt. Another layer of felt is laid over it on top. As the soggy sheets emerge and are tipped out, they are stacked in a pile of multiple sandwiches of interleaved felt and paper. Then the stack is squeezed in a press to remove excess water and the damp paper can be taken out and hung up to dry. When ready, the sheet is 'sized' by lowering it into an animal glue made from boiling scraps of vellum or other offcuts. The size makes the paper less absorbent and allows it to take ink without running. The sheets may have to be pressed again to make them completely flat. Sometimes, especially in north-east Italy (doubtless under the influence of Islamic paper manufacture) the paper was polished with a smooth stone to give it a luxurious sheen.

It happens of course that the wire frame leaves lines where the soft paper pulp is thinner, and by at least 1300 European paper-makers began twisting little patterns out of wire and attaching them to the grid so that amusing or emblematic pictures were coincidentally trans-

leaves are assembled one inside another, folded vertically down the middle and they can be stitched through the middle of the central fold to make a book in its simplest form. The very earliest Coptic manuscripts in 'codex' form (that is, with turning pages rather than in continuous scroll format) were often constructed of a single huge stack of bifolia folded right in the centre of the book, like a fat American Sunday newspaper. The unwieldiness of this led scribes in the early centuries of Christianity to begin assembling their manuscripts out of a whole series of smaller gatherings sewn one beside another. Modern hard-bound books are still made in exactly the same way. Each clutch of folded bifolia is called a gathering or quire or signature. All standard medieval manuscripts are made up of gatherings. This is absolutely crucial. It is probably the single most important observation that can be made about the making of medieval books. A manuscript is a unit formed by assembling in sequence a series of smaller units. Scribes and illuminators worked on a gathering at a time. If one is examining a medieval manuscript carefully today, the first task will often be to peer into the centre of the folded pages looking for the sewing threads and sketching out a physical plan of where each gathering begins and ends. One may then begin to notice changes of scribe

and illuminator, dividing their labour according to the gatherings.

A gathering is usually of eight leaves, or four bifolia. In early Irish manuscripts and in fifteenth-century Italian books a gathering was often of ten leaves. Little thirteenth-century Bibles, which used exceedingly thin parchment, were often made of gatherings of twelve, sixteen, or even twenty-four leaves. Sometimes a book was made up mostly of gatherings of eight leaves but ended with a gathering of six or ten leaves because the conclusion of the text fitted more neatly. Sometimes even within a manuscript there were gatherings of irregular length, and these can be clues as to how the maker put the book together. The Calendar of a liturgical manuscript, for instance, usually has twelve leaves (for the twelve months) and will usually prove to be formed either of two gatherings of six leaves or one of twelve within a book otherwise uniformly in gatherings of eight leaves. In other words, the Calendar was made separately and could be extracted and changed without cutting into any other gatherings. This is a clue not only to the creation but also to the use of the manuscript.

A great deal of effort has been expended by historians of medieval books in trying to determine how the gatherings were actually

12 Unbound gatherings of a fourteenth-century manuscript, formed of folded pairs of leaves inserted one inside another.

made. It is evidently not as simple as it sounds. Let us remind ourselves that there are the subtle differences between what had been the hair side and what had been the flesh side of a sheet of parchment. In handmade paper too, if one can peer closely enough, one can detect from which side the wire lines and watermark were indented. Now open any medieval manuscript. Almost without a single exception in over a thousand years of book production in every conceivable circumstance all over Europe, facing pages match. Hair side faces hair side, flesh side faces flesh side, and in paper manuscripts watermark side faces watermark side. This is quite extraordinarily consistent, and yet no medieval manuals of craftsmanship mention the fact. A break in the sequence of hair to hair, flesh to flesh, is so rare that it is often the first indication that a leaf is missing from the manuscript. It would be pleasant to suppose that scribes were merely hoping for a balanced effect of double pages by matching up the very slight differences of texture between the surfaces; this may be true, but it is too consistent, occurring even in rough volumes where scribes evidently cared little for appearance. The matching of surfaces was obviously so basic that it must have come about without effort.

For what follows we are going to recommend that the reader conducts a simple experiment while following this paragraph. (This may be unorthodox, but it will be infinitely clearer than complicated diagrams or apparently repetitive prose, and the result will be dramatic.) Take an ordinary-shaped oblong sheet of paper coloured or somehow marked on one side. Lay the paper horizontally on the table with the colour side upwards. Now fold it over once with a vertical crease in the middle. It looks tall and thin. It is the shape called folio. Now fold it in half again and crease it along the middle horizontally. It is oblong but a bit squatter in shape. This format is called quarto, because four thicknesses are folded. Now fold it in half yet again. The wad is now an eighth of the size that it began, and the shape is called octavo. Now stop. Imagine this as a gathering in a book, with a central fold and uncut edges like a French novel. Take a knife or a finger and open it up page by page as if you

were reading it. Page 1 is white. Pages 2 and 3 facing each other are coloured. Pages 4 and 5 facing each other are white. Pages 6 and 7 are coloured, and so on. If this were vellum, in other words, no matter how many times you fold the sheet, flesh side will automatically face flesh side and hair side automatically face hair side. Presumably, then, this is more-or-less how gatherings were folded in the Middle Ages.

Now take another sheet. Place it horizontally before you also with the colour side upwards. Fold it over lengthways, making a long strip. Now imagine the strip divided into quarters along its length. Fold the first quarter over and crease it. Then fold both first and second quarters over again covering the third quarter, and crease it again. Finally fold the whole thing over on itself. You are left, as before, with a page-shaped package, an eighth of the size of the initial sheet. Imagine the last fold you have made as the centre of the gathering. Once again, slit it open. Again you will have a gathering of eight leaves with coloured and blank sides automatically facing each other.

In both these simple origami experiments we began with the test sheet colour side up. It makes a model with its first and last pages plain. If the sample had begun with the colour side downwards, the first and last pages would have come out coloured. In manuscripts from the late Roman Empire and from the Greek Orthodox world, the first and last pages of a gathering are the original flesh side. This was revived by the humanist manuscript-makers of fifteenth-century Italy. But for the rest of Europe from the pre-Carolingian to high Gothic periods, the first and last pages of a gathering are the original hair side of the parchment. It must simply be that the classical parchment folders began hair side up, and the medieval folders began flesh side up, and so fixed was the tradition that it seldom varied.

As one folds the sheet in half, in quarters, eighths, sixteenths, and so on, it will always come out taller than it is wide. This is obvious, because the original sheet was rectangular, not square. Evidently parchment was folded to such a formula that when paper was introduced it too was manufactured in a similar rectangular for-

mat, and the folding produced the same effect. But the reason for the shape (to revert to the point of six paragraphs back) is because animals are oblong, and the reason why books even today are taller than they are wide is because in their medieval ancestry there was a millennium when they were made from folding animal-shaped parchment. This is not necessarily anything to do with size. Manuscripts can be absolutely vast, like the choirbooks of sixteenth-century Spain or the thirteenth-century Codex Gigas in Stockholm nearly a metre high, to little jewel-like prayerbooks half the size of a matchbox.

Evidently the simple folding of parchment is not the only explanation of constructing gatherings as it is difficult to see how ten-leaf units come about. (Try, with the same piece of paper; if you solve it you will have added to our knowledge of medieval book production.) The case is complicated further by the tantalising possibility that at least sometimes medieval scribes wrote their gatherings before they had been cut at all. This is an immensely worrying subject. Palaeographers have been driven to distraction arguing one way and the other, basing generalisations on precious fragments which have survived against all odds showing parts of texts written out on entirely uncut sheets with eight pages on one side and eight on the other. The scribe needs to calculate the imposition (page layout on the uncut sheet) correctly: p.1 is in the second quarter of the lower half of the sheet, p.2 is on its verso in the third quarter on the other side, p.3 is next to it to the left, p.4 is on its verso on the first side, p.5 is upsidedown above p.4, p.6 is on its verso again, and so on, all worked out so that when the sheet was eventually folded and cut open all sixteen pages ran on continuously from beginning to end. Durham Cathedral MS.A.IV.34 seems to have been made like this in the twelfth century, but it is surely exceptional. It does not sound a practical everyday method. There is, however, quite good evidence that sometimes gatherings were folded and cut open all except for a few millimetres of joined parchment right in the top corner by the central fold. This allows the leaves to be opened up page by page to be written

without the final snip which would separate them. If the leaves had already become separated, they could be held temporarily by a little twisted vellum ribbon nipped through the inner corner. A very few such fragile ephemeral thongs survive, but mostly they would be trimmed away when the edges were planed in binding. All these possibilities, however, must be regarded with caution. A few chance traces of tacking of gatherings is not necessarily indicative of universal practice.

In the earlier Middle Ages scribes probably assembled their gatherings and wrote in them as they worked through the transcription of a book. By the fifteenth century, at the latest, stationers were certainly selling paper and parchment already made up into gatherings. The inventory of stock of the deceased Florentine stationer and bookseller Giovanni di Michele Baldini in 1426, for example, included gatherings already made up for sale, such as twelve quires of parchment *da Salteri et Donadelli* (suitable for little Psalters and Donatus grammar books) and six quires *da messali* (for big Missals). Fifty years later the inventory of the stock of Gherardo e Monte di Giovanni in Florence included parchment for sale either by the skin or by the gathering and at most stages in between. We may be arguing in circles if we see this as proof that gatherings were pre-prepared. Scribes worked for stationers; for stationers to sell blank gatherings might indicate no more than speculative preparation of more than their own needs.

This has been a long chapter so far and we have not yet approached the moment when the scribe began to write. There is still one further important preparatory stage. Lines were ruled on the pages of medieval manuscripts as a guide for the script. School children today have lines ruled for their handwriting, and exercise-books and ledgers are printed with ruled lines. It is, however, considered now to be not really good manners to write formal letters on ruled paper, as if there were something a bit shameful in needing guidelines for handwriting. It was quite the reverse in the Middle Ages. The smarter the book, the more elaborately it was ruled. Unruled manuscripts (and they exist) are the cheap and

The illustrated manuscript page contains two columns of Gothic script text in Latin:

> ruentt unus de septem an
> gelis qui hbant phialas ꝛ
> locutus est mecum dicens. Veni
> ostendam tibi sponsam uxorem
> agni. Et sustulit me in monte
> magnum ꝛ altum. et ostendit ꝙ
> cuutatem sanctam ierlm descende
> tem de celo a deo habentem claritz
> tem dei. Lumen eius simile lapi
> di pretioso tanquam lapis iaspi
> dis simile cristallo. Et habebat ꝛ
> murum magnum ꝛ altum ha
> bens portas duodecim. Orienta
> lem uidelicet australem et aqui
> lonem preciptꝛ deus utꝛ porta ꝛ

> orientalis clausa super manente ꝛ
> principe tantum modo per eam ꝛ
> tiante exeunte. Et in portis an
> gulos duodecim. et nomina scꝛ
> pta duodecim tribuum filiorum
> ierlm. Ab oriente porte tres ꝛ ab
> aquilone porte tres. ab austro por
> te tres. ꝛ ab occasu porte tres. Et
> in ipsis scripta nomina duodeci
> apostolorum agni. ꝛ cetera.
>
> ruentt unus de septem angls
> qui hbant phialas. ꝛ locutus est
> mecum dicens. ueni ostendam ti
> bi sponsam uxorem agni. et cetera
> Superius in quinta uisione dicit iohannes
> septem anglo huius phialas se fuisse moñstros.

13 A page from the unfinished Apocalypse apparently made for Edward I, perhaps in Westminster before 1272. The script has been written on an elaborately ruled grid of guide-lines. The illustration has been sketched and the gold inserted and burnished, but colours have not yet been applied.

ugly home-made transcripts. Splendidly illuminated manuscripts have grids of guide lines. When printing was introduced and early customers expected their books to resemble traditional manuscripts, the usual trick was to rule in guide lines around every line of printed text because writing presumably looked naked without it. There are examples of this at least into the seventeenth century. Ruled guide lines were an expected feature of a medieval book.

The lines drawn on a page of a medieval manuscript will depend very much on the text to be written. Either the scribe ruled his own, or he selected ruled leaves in accordance with the scale and page layout of his text. There is a ninth-century instruction for laying out pages mathematically. Suppose the page to be five units high and four wide, it says. The height of the written-space should be four such units. The inner and lower margins should be three times as wide as the outer margin and as the gutter between the columns (if it is a two column book) and a third wider than the width of the upper margin. The lines should be spaced, the ninth-century directive concludes, according to the size of the writing. It is quite difficult to measure out a page according to these rules. Probably most manuscripts were simply arranged as elegantly as practicable without elaborate mathematics. It can be hard to confirm whether extant manuscripts followed a formula of proportion, because their three outer margins are likely to have been trimmed a number of times in rebinding over the centuries. If nothing else, however, medieval book designers probably realised that in a handsome manuscript the height of the written-space equalled the width of the page.

The number of columns varies with the century and with the text. Very early codices often have several columns, presumably echoing their evolution from rolls, and early Irish books can be in one or two columns. Carolingian manuscripts and their Italian Renaissance imitations are usually in one wide column. Romanesque and Gothic textbooks are generally in two columns. French and German literary romances, with short lines, are frequently in three columns. Books of Hours are usually in

14 The illustration of St Matthew from the twelfth-century Dinant Gospels shows the evangelist ruling a manuscript by scoring lines across a double page.

one column, and Breviaries usually in two. Glossed biblical manuscripts are usually in three columns: a broadly-spaced central column for the scriptural text and narrowly ruled outer panels for the commentaries in smaller script. Law texts often have a double column central block with three-sided compartments of gloss fitting to the left or the right around the main text. Some page layouts are so distinctive that one can identify a text at ten paces, without reading a word.

Until the twelfth century, most manuscripts were ruled in drypoint, that is, with blind lines scored with a stylus or back of the knife. Scribes ruled hard and sometimes cut through the parchment by mistake. Around the beginning of the twelfth century we first find guide lines ruled in what looks like pencil: it could be graphite but is more likely to be metallic lead or even silver. Oblong pieces of lead have been excavated inscribed with names like ROGERII and KAROLI SCRIPTORIS in thirteenth- or fourteenth-century capitals, and are probably plummet markers for just such purposes as ruling manuscripts. From the thirteenth century onwards, concurrently with plummet (sometimes even in one manuscript), lines can be ruled in pen and ink. We find brown, red, green or purple ink used, and sometimes combinations of colours giving a festive appearance. Patient codicologists have tried to count up all the different possible patterns of ruling, recording literally hundreds of varieties but wresting very few conclusions from their statistics. Very often the lines marking off the block of text continue right to the edge of the page, and sometimes they are double or treble. The horizontal lines for the script sometimes extend to the edges too, or perhaps the first and last will, or the first, third, antepenultimate, and last. It is interesting to look at a manuscript and notice how it has been ruled, but it is not easy to draw any particular generalisations about what one sees.

Ruling page by page before even beginning to write was slow and tedious. Various devices were used to speed the process. The most universal was to measure out the first page of the gathering, or the first and last page together if the gathering was laid open, and to follow the

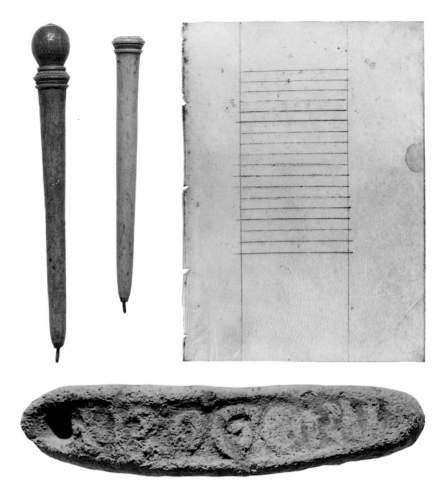

15 *Top left* Medieval styli, made of bone with metal tips, of the type probably used for scoring the ruling patterns in manuscripts until the twelfth century.

16 *Above* A stick of lead, or plummet, suitable for ruling lines in Gothic manuscripts. This English example, marked with the name of its owner ROGERVS, may have been cast in the thirteenth century.

17 *Top right* A page of a fifteenth-century French Book of Hours ruled up in ink in preparation for writing.

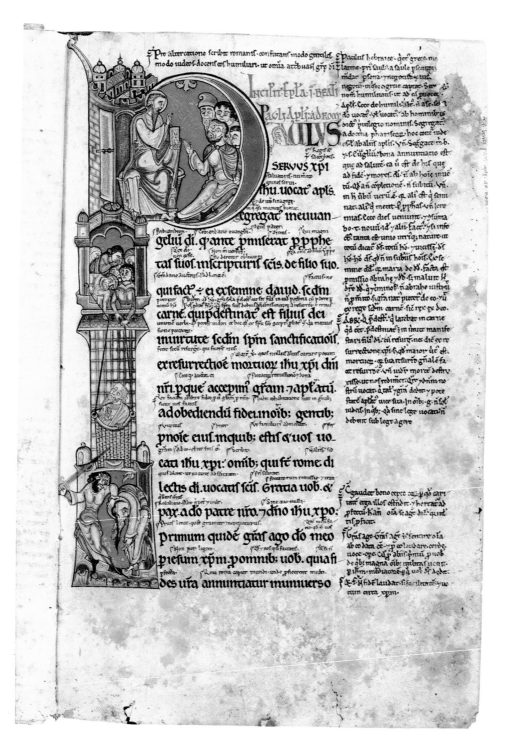

18 In the centre of each area of pigment in this twelfth-century English miniature can just be seen a tiny letter of the alphabet to indicate the colour to be used. It suggests that the design was drawn and marked up by one artist and coloured by another. The picture shows scenes from the life of St Paul, and was perhaps made in Winchester.

19 *Opposite* A remarkable unfinished and entirely uncut sheet of a late fifteenth-century French Book of Hours, which must have been written before it was folded.

lines with a rule to the extreme edge of the page and there to prick very hard right through the whole stack of leaves. Then all that was needed was to open the pages and join up the prickings and the ruling pattern would be duplicated exactly from page to page. Sometimes these holes were apparently pricked with the very tip of a knife because they are the shape of tiny triangular wedges. Usually they must have been pushed with a carpenter's awl, a metal spike on a wooden handle.

Prickings are not always visible as they are frequently trimmed off in binding. If they occur in the inner margins as well as the outer margins, the leaves must have been ruled while the gatherings were folded into pages. Occasionally one notices (especially if alerted to look out for it) that every eight or ten lines or so one hole will be crooked or unduly widely spaced. If this is consistent in several gatherings, it is a good clue that the prickings had been made with some kind of wheel, like a tiny garden roller with spikes, and that one spike had somehow become knocked out of alignment and thus the defect recurred at regular intervals as the wheel went round. There is sometimes evidence too in the later Middle Ages that the multiple lines for the text were ruled with several pens tied together, like the *rastrum* or rake used for making musical staves. If for any reason these pens were knocked or quivered slightly as they were drawn across the page, the quaver is reflected at exactly the same point in several lines simultaneously. This is another clue worth looking out for in a page of manuscript.

A final artificial device, used only in the fifteenth century (as far as can be traced) and mostly in north-eastern Italy, is the ruling frame. This is a familiar feature of Oriental and Hebrew book production. Holes are drilled in a wooden board and wires are ingeniously threaded through, emerging in a criss-cross pattern exactly like that of the framework to be transferred onto the page. Then all that is needed is to place the blank sheet over the board and rub it with the fist, and the lines will be impressed identically onto the sheet. An inventory of a paper-merchant in Perugia in 1463 includes *due tabule ad rigandum*, presumably two frames like this.

Once more, as with other ruling devices, it is not necessarily easy to tell when confronting a manuscript if a ruling board has been used. But imagine how the wires must bisect each other on the board when they cross at right angles. One must be threaded under the other or pushed right through the wood and out again on the other side of the wire it crosses. One can see this in the manuscript, as no line actually crosses another; the lines stop fractionally short and pick up again a millimetre on the other side of the crossing. When a line is ruled with a stylus, it simply ploughs straight across, one way and the other.

In the early Middle Ages, scribes doubtless prepared many of the stages of the parchment themselves. The cottage-industry of the monastic cloister left little scope for teams of professional collaborators. Even the parchment was doubtless a by-product of the monastery's kitchens, and paper was unknown. But certainly by the fourteenth century it seems to have been possible to purchase gatherings of parchment ready prepared for writing. Ruling continues under miniatures, and there is ruling on blank flyleaves. For many scribes, the task of writing a manuscript must have begun with neat stacks of paper or parchment gatherings, ready folded and ruled.

20 Pages were measured for ruling, and the extremities of each line were pricked with an awl right through the stack of unwritten parchment. The scribe had simply to join up these prickings to reproduce the ruling pattern exactly on subsequent pages.

Manuscripts are written by hand. Everyone is familiar with the image of the medieval scribe copying texts with a quill pen: it is quite correct. The inks were thicker and more glutinous than modern commercial ink, and there are numerous medieval recipes for their manufacture. We shall consider these in a moment. But there are almost no medieval instructions for the cutting of pens. There are allusions in Isidore of Seville, for instance, to the different nature of reed and quill pens in the seventh century, but nothing on their manufacture. All literate people evidently prepared their own pens and there was thus no merit in writing about how it was done. The cutting of a quill must have been entirely obvious and so familiar to every educated per-

son from ancient Egypt to nineteenth-century England that it was not thought worthy of mention.

Modern scribes who use quill pens have evolved their own methods of preparing them, and these are likely to be as accurate for the Middle Ages as any historical research by re-enactment can ever be. The best feathers prove to be the five or so outer wing pinions of goose or swan. Theophilus in the twelfth century asserted that goose quills were the best. It is sometimes claimed that the microscopic scripts of the university scribes were made with crow or raven quills. This is technically quite possible but a small pen is difficult to hold, especially if writing a Bible a thousand pages long, and tiny

21 A reed pen and two quill pens. The upper pen has been used for laying gesso, coloured with pink bole, and the lower pens are both stained with ink.

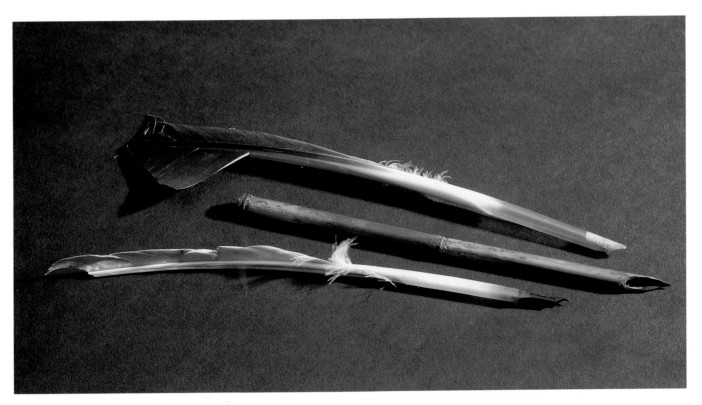

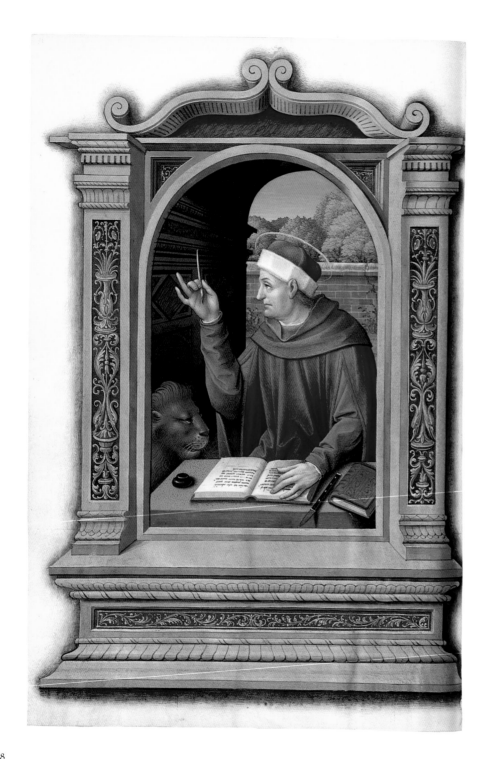

22 St Mark, shown in a French Renaissance Book of Hours as a scribe who has been cutting his quill with a penknife and is now checking the tip before dipping it in his ink bottle.

script may after all be the result of a bigger quill cut to a finer tip. Turkeys, which produce excellent quills, are native to America and were unknown in medieval Europe.

For a right-handed scribe a quill which fits most comfortably into the hand has a slight natural curve to the right. This, then, comes from the left wing of the bird. First of all, the thin end and most of the barbs would be trimmed or peeled away and medieval pictures of scribes show simply the curved white barrel. Feathers freshly removed from the bird, or found on the beach, are too flexible and need hardening. They can either be left to dry out for some months or can be hardened artificially by soaking them in water and then plunging them for a few minutes into a tray of heated sand. The thin greasy outer skin and pith within the barrel can be scraped or rubbed away easily now. What remains is a tough and almost transparent tube. The tip is pared away on each flank with a short and sharp knife – a penknife – usually in a double step, very much into the shape of a fountain pen nib. Then it is cushioned in the hand (rather like the action of peeling a potato) and a slit is cut up the centre of the nib. Finally the pen is laid with its nib against a firm surface and the scribe pushes down with the blade of his knife across the extreme end, removing a fraction of a millimetre to produce an absolutely clean crisp squared-off tip.

A modern scribe, demonstrating quill-cutting to a circle of admiring medievalists, can follow through these separate stages in a few moments of rapid scattering of parings. The medieval scribe doubtless prepared his pen at consider- able speed and without great effort. The final cut across the tip has to be repeated quite often in the course of writing out a manuscript as the slit in the point will open up with use or with neglect. John of Tilbury, one of the scholars in the household of Thomas Becket in the twelfth century, describes how a clerk taking dictation would need to sharpen his pen so often that he had to have sixty or a hundred quills ready cut and sharpened in advance. The implication is that in the course of a day's work a busy scribe would sharpen his pen sixty times.

Medieval pictures of scribes in action are remarkably common, either as author portraits at the opening of their texts, or as part of the standard iconography of evangelists and of St Jerome in his study. Thus there are illustrations of people with pens from all periods of the Middle Ages. Especially in Books of Hours, which often open the section of Gospel Sequen- ces with a miniature of St John writing on the island of Patmos, we see the Saint peering at his pen, sharpening it (pulling the blade towards him, not away as we might sharpen a pencil), scraping it with a knife, licking it, writing with it, propping it behind his ear, and so forth, all intended to represent familiar homely activities of the manuscript maker. It is interesting too to notice how medieval writers are depicted hold- ing their quills because it is not as we hold pens now. Most of us grasp writing implements between the tip of the forefinger and the first knuckle of the middle finger, secured firmly in place by the thumb. (Try it: it is easier than explaining.) The medieval scribe, to judge from pictures, held his pen pointing downwards on the inside of the tips of the middle and forefingers while holding it steady by the very tip of the thumb. The fourth and fifth fingers are curled up out of the way. In this way the quill meets the page much more vertically than a modern pen. Ink seems to flow better when a quill is at right angles to the page. The medieval way of holding the quill gives less finger control than a modern pen and so movement comes from the whole hand. The quill itself, however, is infinitely lighter than a modern pen and it glides across the page without great effort. A proper understanding of the formation of medieval script should begin with some aware- ness that the pen was held differently.

The quills were what we would call dip-pens. A scribe cannot write without a pot of ink, and the miniatures of St John on Patmos sometimes include the figure of a mischievous devil who creeps up behind a bush with a grappling-hook to spirit away the Saint's ink pot. This is an open-air scene and so the pot is portable, presumably with a screw lid, and it is attached by a cord to an oblong pencase. Not dissimilar pen and ink sets are used by Islamic scribes today, and doubtless it was a familiar image to

23 St Luke, in a Book of Hours of about 1430, seated at a sloping desk and sharpening his pen by pulling the knife towards himself.

24 A scribe cannot write without ink. Miniatures of St John recording the Book of Revelation (this example is from a Rouen Book of Hours of about 1480) sometimes illustrate the legend that the Devil tried to steal the evangelist's portable inkpot and pencase to prevent him writing this last book of the Bible.

25 A late medieval inkwell made of decorated leather.

the medieval scribe on the move. In the scriptorium ink was held in inkhorns; some scribes are shown holding these horns but usually both hands were occupied with knife and pen. Sometimes saints are shown with the good fortune of angels holding up their ink-horns in readiness. Evangelists depicted in Carolingian Gospel Books often have their ink on a separate stand, like a torchère, beside the desk (a sensible precaution if one is prone to knock the pot over). In late medieval pictures the horns are generally inserted into metal hoops attached into the edge of the right-hand side of the desk, and there are frequently two and sometimes three at once. There are ex-amples where the horns are fitted into a vertical row of holes in the surface of the desk itself and their tips can be seen protruding below the table. St Matthew as shown in the *Très Riches Heures* of the Duc de Berry has his inkhorn conveniently inset into the arm of his chair.

There are a fair number of medieval recipes for making ink. There were two completely different types of ink and it will be as well to distinguish between them at the outset. The first is carbon ink, made of charcoal or lamp-black mixed with a gum. The second is metal-gall ink, usually iron gall, made by mixing a solution of tannic acids with ferrous sulphate (copperas); it too requires added gum, but as a thickener rather than as an adhesive. The blackness is the result of a chemical reaction. Both types of ink were employed in medieval manuscripts. Car-bon ink was used in the ancient and eastern worlds and occurs in all medieval recipes (there are many) until the twelfth century. This need not imply that it was the only method until that time, because high medieval accounts of crafts-manship are more likely to re-tell a classical or literary source rather than to branch out into contemporary experience. There were certainly iron-gall inks in use by the third century, but there is no literary tradition of explaining them until Theophilus in the earlier twelfth century. Thereafter craftsmen's recipes describe gall inks, and probably almost all later medieval manu-scripts are written with iron gall.

The recipe is interesting, and it may come as a surpirse to learn that a principal ingredient is the oak apple, the curious ball-like tumour, about the size of a small marble, which grows mainly on the leaves and twigs of oak trees. It is formed when a gall wasp lays its egg in the growing bud of the tree, and a soft pale-green apple-like sphere begins to form around the larva. One can find galls quite easily on shrub oaks, even today, though the finest specimens were said to be those imported from Aleppo in the Levant. If picked too young, gall nuts shrivel up like rotten fruit; but when the larva inside is fully de-veloped into an insect, it bores a hole out of its vegetable cocoon and it flies away and the hard nut which remains is rich in tannic and gallic acids. These are roughly crushed up and infused for some days in rainwater in the sun or by the fire. The physician Pietro Maria Canepario wrote in 1619 that this could be speeded up by boiling the crushed galls for as long as it takes to recite the *Pater Noster* three times. Sometimes white wine or vinegar was used instead of rainwater. This, then, is the first ingredient of iron-gall ink. The second is ferrous sulphate, known also as copperas, green vitriol, or *sal*

martis. Both Dioscorides and Pliny write about copperas. It was manufactured or found naturally in Spain by the evaporation of water from ferrous earths. By the late sixteenth century, copperas was probably being made by pouring sulphuric acid over old nails, then filtering the liquid, and mixing the filtrate with alcohol (this may explain the acidity of post-medieval inks). The copperas is then added to the oak-gall potion, stirred in with a fig stick (according to Palatino in 1540, as if the ingredients were not obscure enough already); 'stere it ofte', said an English recipe of *c.*1483. The resulting solution slowly turns from pale brown into black ink. Some ground-up gum arabic is added, not so much to supply adhesive but to make the ink thicker. Quill pens need the viscosity of gum; fountain pens, in fact, do not. Gum arabic, which we shall come to again in accounts of medieval pigments, is the dried-up sap of the acacia tree, brought to Europe from Egypt and Asia Minor. Ink-making is in many ways a wonderfully romantic process, redolent of alchemy.

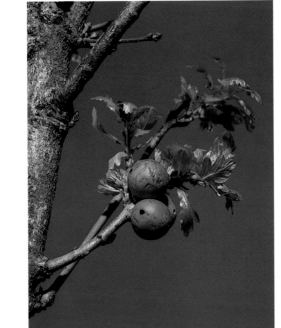

26 Oak galls, growing on a branch of an oak tree. The tiny hole in each shows where the newly-hatched gall wasp has escaped.

Iron-gall ink darkens even further when exposed to air on the pages of a manuscript. It soaks well into parchment, unlike carbon inks which can be rubbed off relatively easily. It is more translucent and shinier than carbon ink which is grittier and blacker. Iron-gall ink was used for well over a thousand years, and Anglo-Saxon specimens have survived as admirably from the beginning of the period as Victorian inks from the end.

Medieval pictures of scribes, as mentioned above, sometimes show two inkhorns on the right of the desk. The second container was probably for red ink. Red was used greatly in medieval manuscripts, for headings, running-titles and initials, for rubrics (hence the word) in liturgical manuscripts, and for red-letter days (hence that term too) in Calendars. Corrections to the text were sometimes made in red, drawing attention to the care with which a text had been checked. Blue and green inks exist, but are rarer; red was always the second colour. We have the detailed account for the writing of a Gospel Lectionary by a canon of Windsor in 1380. Apart from the cost of labour and board and lodging for the scribe, the materials needed were itemised as parchment at 8d. a gathering, ink at 1s.2d., and vermillion at the comparatively high price of 9d. The vermillion is for red ink, and was a major ingredient in the contract. Red ink in manuscripts goes back at least to the fifth century and flourished until the fifteenth. It must have been the spread of printed books, in which producing coloured text is very complicated, which eroded the doubtless standard medieval assumption that books were black and red. Printed books are just black, which is duller. Vermillion is mercuric sulphide, and is turned into red ink by grinding up and mixing with white of egg and gum arabic. Red ink can also be made from brazilwood chips which were infused in vinegar or urine (apparently) and stirred in once more with gum arabic. Brazilwood, one should explain, is not a native of South America – the country was named after its abundance of the well-known trees already familiar to makers of medieval red ink.

By now, after recounting the assembling of ingredients, one might suppose the scribe was

27 Coloured inks were frequently used in medieval manuscripts. Especially in Paris, the names in the Calendars of Books of Hours were often written in red and blue ink with headings and principal saints' days in burnished gold.

ready to begin writing. There is, however, still a crucial piece of equipment without which almost no manuscript can be made. A scribe does not simply write: he copies and must have an exemplar from which to reproduce the text. This is already presupposing that the scribe has decided *which* text is to be transcribed next: that would make a fascinating study in its own right, if only enough evidence could be assembled on the motives for selecting texts and on the order in which desiderata were tackled.

If the scribe were a monk, working only for his monastery's own library, there might be little urgency to reproduce a text already represented in the collection, but if the text was not in the library there is then the even more intriguing problem of how the scribe knew about the text anyway (especially a new text by a distant author) and, if he did find references to it elsewhere, of how he was able to borrow an exemplar to copy. Answers to these questions take us right to the heart of intellectual and cultural history and have to be beyond the scope of this book. There was evidently a

surprising amount of travel between one monastery and another, and a great deal of carrying about of manuscripts. There exist early Irish manuscripts with contemporary ownership inscriptions of German abbeys, Parisian university manuscripts from the libraries of remote English monasteries, Italian legal manuscripts which wandered when newly-written into France, and so forth. There are also letters from one abbey to another, either requesting the favour of having a text copied and sent, or asking if an exemplar could be made available. Nonetheless, it is a tantalising question, and glimpses from thousand-year-old monastic correspondence or apparent textual links between surviving manuscripts supply only a partial answer.

By the time of the secular workshops of the Gothic period it was not necessarily easier to find exemplars because of the infinitely greater number of texts in circulation. Surely texts like Bibles in the thirteenth century and Books of Hours in the fifteenth century, which were the stock-in-trade of medieval booksellers, were copied from exemplars owned on the premises. It may be that some of the grubbier surviving copies served their time as exemplars in the Middle Ages, but no indisputable exemplar is known for either text. Sometimes, no doubt, a customer simply walked into the scribe's shop with a manuscript under his arm and commissioned a copy. Most of the very early booksellers and professional scribes were concentrated in the university towns and exemplars were certainly more easily available in Paris or Oxford, for example, than in provincial villages.

One of the earliest recognisably professionally-made manuscripts from Paris is a copy of Ptolemy in the Bibliothèque Nationale with an inscription recording its completion in December 1213 from an exemplar in the abbey library of St-Victor in Paris, and by chance the St-Victor copy of the same text still survives and is now also in the Bibliothèque Nationale, allowing us to place the monastic original and the secular copy side-by-side again after nearly 800 years. The humanists raided monastic libraries in their search for lost classical texts, carrying off the originals to use as exemplars, if they were allowed, or copying the texts *in situ*, if they were

not. In the thirteenth and fourteenth century, certain university towns, mainly Paris and Bologna, operated a kind of exemplar loan service whereby a wide range of student textbooks could be hired out for copying a gathering at a time. Each of these gatherings was known as a *pecia* and could be rented from an authorised university stationer. There were published lists of the texts available and the cost of hiring each part of the exemplars. There are many complications in interpreting the mechanics of the *pecia* system (and it is not appropriate now to delve into its remarkable ramifications as this would distract the story even further from the actual craftsmen involved in book production) but one must accept that the keeping, borrowing, begging, or hiring of exemplars was an important preliminary to the business of writing a medieval book.

There are at least two portraits of the Flemish scribe Jean Miélot in manuscripts of the third quarter of the fifteenth century. Both show the exemplar propped open on a lectern just above the scribe's own sloping writing-desk. The lectern appears to be double-sided and supported by a metal swivel attached to his own desk so that Miélot could move it round to just above his eye level while copying and could presumably rotate it to compare another exemplar on the back or could swing the entire lectern out of the way. It looks very ingenious and may contain an element of wishful fantasy. The evangelist and author portraits we considered earlier for their depiction of scribes are less helpful in showing exemplars because in divine revelation there is supposed to be no exemplar at all. St Gregory is often shown writing as the Holy Dove whispers in his ear. Both the exemplar and the copy were usually simply placed side-by-side on a sloping desk. We can see in miniatures that manuscripts were held open by weights hanging from each end of a string, with one end dangling over the back of the desk and the other hanging down across the top of the page. A parchment manuscript will tend to close itself unless it is held open. Sometimes the weights are shown as more-or-less triangular with rounded tops and extended horizontal lower edges. As the scribe copied a

28, front cover

molestez cest leur secours joyeux Cest le repos
de tous les langoureux Cest leur salut et
remede courtoys · Et pour brief dire vng
tresaffectueux · Lit prepare au fil du roy des
roys · Maistre prenez repos solacieux · En
te saint lit jour seymaines et moys · Coe
en cellui qui fu tresdesireux Lit prepare
au fil du roy des roys ·

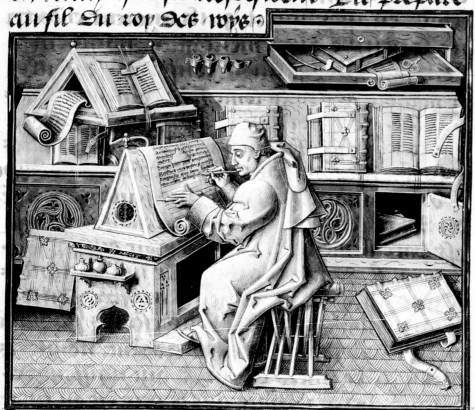

28 Jean Miélot (*d.*1472) was
a canon of Lille and secretary
to two Dukes of Burgundy,
Philip the Good and Charles
the Bold. He was also a
notable translator and scribe.
He appears in this celebrated
miniature as the ideal scholar-
scribe in a study filled with
manuscripts and the
implements of his labour.

Sensieut vng petit prologue sur lassuptio dela vierge
marie translate de latin en francois · Par Jo Milot
...letus serviteur deihucrist en leglise
desarde Ases venerables fre e nres
Demourans alasenc salut Je me
ramembre bien que jay souvent escript ·

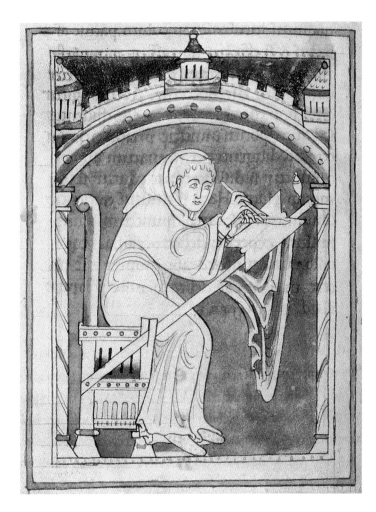

29 Laurence, prior of Durham 1149–54, is depicted as a scribe in a contemporary manuscript of his own works, still preserved in Durham. He is shown steadying his page with a knife held in his left hand.

text, it would be relatively easy to pull the weight down the page so that the long horizontal edge of the weight would very effectively mark his exact place in the exemplar.

Scribes sat very upright, often on tall backed chairs (to judge from pictures again), before a sloping desk. Some medieval illustrations show the desk top actually attached to the chair, apparently hinging up to let the scribe sit down and then falling down again into place, rather like a baby's highchair. Looking at the pictures, however, it is difficult to envisage how the scribe wriggled into the seat; even with the hinge up. The slope is quite steep. As mentioned, quill pens are most effective when held at right angles to the writing surface, and this is easier to achieve on a slope. It is tiring for an unpractised modern writer to work on a steep slope because the way we hold our pens requires the resting of the edge of the hand on the page and manipulating the fingers. But a pen held as described earlier scarcely requires the hand to touch the page at all and movement is from the arm. For this, the flexibility of a sloping desk is ideal. As ink takes some moments to dry, one can sometimes see on the pages of medieval manuscripts that the concentration of ink is in the lower edges of the letters as it has settled down the slope of the desk.

As the scribe sat down to commence copying, he was recommended by the recipes to give his parchment a final rub over with fine pumice and to smooth the surface off with chalk. This is to remove any grease stains that may have come about in handling and folding the sheets, and to reduce the risk of the ink running. He probably tried out the pen with a few words on a scrap of vellum. One sometimes sees phrases on flyleaves such as 'probatio penne', or 'Edwardus dei gratia rex', as meaningless as 'testing, 1-2-3' over a loudspeaker at sports' day, or invocations such as 'assit principio meo ihesus maria' (or 'franciscus', perhaps if it was a Franciscan scribe) written in tiny script along the very upper margin of the first page. As he actually wrote, the scribe held a knife in his left hand. This is important, and universal in the Middle Ages. Writing, like eating, was a two-handed operation. It meant, among other things, that he had

30 Professional medieval scribes were required to write in a variety of different scripts as commissioned by the client or as appropriate to the text being copied. This is a rare survival of a fifteenth-century scribe's specimen sheet on which he advertised all the scripts he was capable of writing.

no spare hand for following his place in the exemplar. The knife was for sharpening the pen and for erasing mistakes (quickly, before the ink had really soaked in) and, more practically, for holding down the always springy surface of the vellum, moving along the line as the scribe wrote each word. To steady the page with the finger is potentially greasy and clumsy, but a knife tip gives precision and control.

This is not the place to write a history of medieval script. It is a subject which becomes more and more complicated with greater experience. A scribe working alone at his desk had no notion that his own script was part of a continuing evolution and would be capable of several contemporary scripts appropriate to the text he was writing: display script for headings, grand noble letters for Missals, quick cursive hands for vernacular literature, charter hands for documents, and so on. Analysis of major early monastic manuscripts sometimes reveals evidence of what seem to have been master and pupil scribes. A good scribe starts the book, and then a less competent hand writes some paragraphs, then the first hand returns (as if demonstrating and re-emphasising some point), and then back comes the trainee with a longer stint, and so on, until the whole book is finished by the pupil in what is perhaps his qualifying piece. House styles of script were in this way passed on from one generation to the next, but were so contaminated by other influences (including the exemplar, so often from elsewhere) that rarely can a manuscript be attributed to a particular workshop on script alone.

One cannot generalise about how individual letter-forms were drawn. It is usually easier to pull a quill pen downward on a page than to push it up, and so round shapes like 'o' would be simpler to execute with two or more downstrokes than one circular loop; but so much depends on the particular script being written. If one looks carefully at the individual letters of any manuscript, especially with pencil in hand, it is not difficult to establish to one's own satisfaction the order in which individual strokes were made. Mimicking medieval hands is a diverting pastime. A convincing forgery of a whole book would be so difficult to achieve that imitation is a hobby which runs little risk of criminal temptation.

Professional Gothic scribes were capable of several scripts, and a number of display posters have been discovered demonstrating ranges of hand which the scribe could offer to clients. Pieces of an early fourteenth-century parchment poster have been found as part of the stiffening inside a bookbinding demonstrably made in Oxford around 1340. The fragments come from a single sheet, written on one side only in a whole range of different Gothic scripts, and they are stained and weathered. The supposition is that the poster was once tacked up outside a stationer's shop (presumably in Oxford) until it became obsolete or was replaced and so was taken down and stored as a useful scrap of thick parchment. One day its pieces proved ideal for padding out a binding, and thus the oldest known English public advertisement has come down to us. It shows short specimens of twelve different scripts for different classes of liturgical manuscript, from a large choir psalter to little portable processionals with music. There are similar Continental specimens from the fifteenth century, advertising the range of hands available from the scribes Herman Stepel, of Münster in Westphalia, for example, or Robert of Tours, in the diocese of Nantes. Presumably the customer came into the shop, looked over the patterns as one might a menu in a takeaway restaurant, and left an order for a particular script.

A commercial scribe charged by the gathering. There are interesting accounts for making manuscripts in a cache of six fifteenth-century English manuscripts in Peterhouse in Cambridge. They are big thick manuscripts of St Augustine and St Jerome. Each ends with an itemised breakdown of the cost, so much for parchment, so much for writing the text, so much for illumination, and so much for the binding, with a total price. Vellum is 3d. a gathering for books under twelve inches (30 cm) high (MSS.110, 142, 154, 193 and 198) and 6d. a gathering for the one larger book (MS.88). The writing is 16d. a quire for the five smaller books and 20d. a quire for the bigger one. The binding up of the gatherings cost 2s. and 2s.6d.,

31 A portion of a specimen sheet of a fourteenth-century Oxford scribe.

32 The cost survives for making this fifteenth-century English manuscript of St Augustine. The scribe charged a penny a page, and the vellum cost 3d. a gathering.

according to size. The same price of 20d. a gathering was charged for the writing of a Psalter bought by the Paston family in 1467.

The gathering was the unit of production and the scribe on completion of his task would have a stack of separate quires ready to be divided among the illuminators or sent away to be bound. It was obviously very important that the gatherings should be kept in order or be capable of reassembly in sequence without risk of confusion. The earliest western manuscripts had their gatherings numbered on the last page of each, either numerically or alphabetically, A, B, C, and so forth, sometimes preceded by 'Q' (*quaternion*). This served its purpose splendidly in the ages of monastic book production when work was leisurely and in-house and there was little danger of confusing the gatherings of one manuscript with those of another. But by the twelfth century, as manuscript production became a larger enterprise, scribes adopted catchwords instead, writing them in the lower inner corner of the last page of each gathering. A catchword anticipates the first word of the following gathering. A binder simply has to match up each catchword with its twin at the top of the next gathering to assemble the book in its correct sequence. In any hand-made book, the exact number of words a scribe will have copied over sixteen pages will vary from one transcript to another, and thus even if (by chance) a shop was preparing several copies of the same text in the same format at the same time and even if all the gatherings were muddled up, it would still be possible to put them back in order because every pair of catchwords would be unique to that copy. Sometimes catchwords were decorated, and usually they were horizontal but fifteenth-century Italian examples were sometimes vertical. Much depended on the whim of the scribe, and to note the form of catchwords is one method of beginning to distinguish the work of individual scribes.

When a manuscript was finished, the text was usually checked for errors, either by the scribe himself or by a colleague. It is very difficult to copy without making some mistakes, and very many pages of medieval manuscripts show evidence of corrections, either by erasing and re-

33 *Above* Catchwords: at the bottom of the last page of one gathering the scribe of this fifteenth-century Italian manuscript has written the first words of the opening of the next gathering.

34 *Above right* A quire signature: the number 6 in roman numerals within radiating flourishes in the centre of the lower margin of the last page of the sixth gathering in a late twelfth-century manuscript.

35 *Right* A catchword written vertically near the inner margin of an Italian humanistic manuscript of about 1480.

36 writing words, or by inserting omissions in margins, or by crossing out repetitions. Some of the most common are caused by eye-skip. A scribe copies out a sentence and looks back at the exemplar, bearing in mind the last letters he has just written, and his eye settles on another word which ends the same way and he begins copying from there in error. In Latin, as it happens, many words have the same endings, especially verbs at the finish of sentences, and so this is a real risk. In late Gothic manuscripts which the scribe did not expect the client to read very carefully and which were as much for show as use (such as Books of Hours), there was a scribal practice of adding a discreet row of dots under a word or phrase which ought not to be there. It indicated that the scribe was aware of the mistake but that everyone agreed it would be a shame to spoil the handsome look of the page with an erasure or deletion.

The final words that a scribe wrote in a manuscript may simply be the end of the text. Frequently there is an *explicit*, announcing that this is the conclusion of such-and-such a text, very often with the name of the author. Sometimes the scribe signs the book. Scribal signatures are not as rare as one might suppose. Over the recent decades the Benedictine monks of Le Bouveret in Switzerland have been publishing their vast index of colophons of signed medieval manuscripts and their list, which is far from exhaustive, records just on 19,000 signatures of scribes in colophons of medieval manuscripts. The old image of the anonymous craftsman needs to be re-thought. Some scribes simply sign themselves Johannes, or Rogerius, which tells us very little. A gratifyingly large number are women, which one might not have expected. Some names appear often enough that one can start to plot careers of professional scribes, especially in fifteenth-century Italy. Quite often medieval scribes were not full-time copyists of books. They may have been owners making books for personal use, or notaries, students between lectures, moonlighting royal clerks, parish priests unable to live on their stipends, inmates of the debtors' prison, and so forth. Perusing through the volumes of colophons gives glimpses of human life on every

36 All scribes make mistakes from time to time in copying texts. In Bibles in particular any corrections were sometimes proudly enclosed in red frames in the margins in order to proclaim that the transcription had been systematically checked for accuracy.

37 A scribe's colophon at the end of a very long biblical commentary of about 1300 expresses his relief at finishing, and his desire for a drink and for a considerable payment for all his labour.

page. The most amusing colophons in medieval manuscripts are those in which a scribe triumphantly declares his delight in completing the task, often to a formula of complaining of the length of the book or asking for eternal life, or a good jug of wine, or a pretty girl.

Many medieval manuscripts are decorated. By no means every copy includes rich illuminated borders and miniatures, which to many people are the great delight of manuscripts, but it is unusual for a completed medieval book to comprise nothing but plain regular script. From late antiquity there began the custom of enlarging the first letter and filling it in with colour, and the earliest Irish manuscripts at the beginning of the seventh century already show text divided into sections each marked by a big penwork initial ornamented with interlaced patterns and simple animal forms. For the next eight hundred years even the humblest text manuscripts usually opened with an enlarged initial on the first page, and indicated chapters or other subdivisions in the text with similar but slightly smaller capitals. Medieval books have no title pages. The opening initial has the practical function of introducing or announcing the beginning.

In the early Irish manuscripts the initial of the first word is very big, the next letter is not quite so large, the next slightly smaller again, and so on, diminishing down letter by letter to the size of the text itself. So too throughout medieval manuscripts there are initials of different sizes, depending on their position and function in the text. This is what is often referred to as the hierarchy of decoration, and it is an appropriate word for the Middle Ages when people had a strong sense of the gradation of things. Angels, stars, animals, kingdoms, officers of church and state, feudal households, and so on, were all classified into levels of unalterable rank and status with much more assurance than today, and a similar hierarchical sense of the order of things is inherent in the ornamentation of texts. This may sound complicated, but it is actually quite important. If, for example, we are confronting manuscript Bibles or Books of Hours or illustrated literary texts, which have many component parts, we can only begin to judge the design when we realise that in selecting ornament the makers have deliberately apportioned levels of status to each section.

There is a whole range of choices for decoration from lavish full-page miniatures, or even cycles of miniatures, down to small initials in red or blue or capital letters splashed with a dab of red or yellow. There can be partial or full borders and these can be quite simple or joyously crammed with ivyleaves and acanthus scrolls with birds, rabbits, monkeys, and grotesques. Decoration can be in full colour, with or without gold, on the first page only or throughout the manuscript. It is quite impossible to summarise all the different possibilities, and part of the real delight of handling medieval manuscripts is that every one is different. But within each manuscript, one should stress again, there are pre-determined and recognisable gradations of ornament.

In the York Chapter Acts for 26 August 1346 there is the record of a scribe Robert Brekeling appearing before the Cathedral Chapter and confirming under oath to keep his contract to make for his client John Farbor a manuscript Psalter and Office of the Dead with a Hymnary and Collectar. The hierarchy of illumination is laid down precisely. The initials for Psalms 1 and 109 are to be six or seven lines high (these, it happens, are the opening psalms for Matins and Vespers on Sundays). The initials marking each nocturn are to be five lines high. Each psalm and every double feast in the Hymnary and Collectar is to begin with a big initial in gold on a multicoloured ground. Ordinary feasts in the Hymnary and Collectar are to open with enlarged initials in gold and red. The small versal initials of every psalm are to be in blue and red throughout. All this was prescribed before the work began. John Farbor was evidently one of those customers who liked to know exactly what he was getting for the 16s.9d. that this book was estimated to cost.

We can now consider the sequence of making a medieval manuscript. It has long been recog-

back cover,
39

38

38 Decoration in the early Northumbro-Irish manuscripts has the function of introducing each text, and of breaking the page into visual sections which make it easier to use. This is the opening of St John in the Echternach Gospels, written perhaps at Lindisfarne around the year 700.

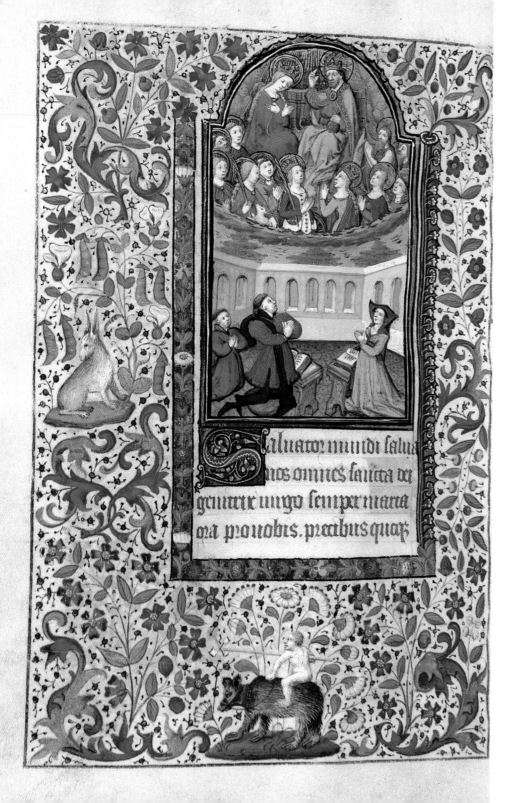

Saluator mundi salua
nos omnes sancta dei
genitrie uirgo semper maria
ora pronobis. precibus quas

39 The original owners of this Parisian Book of Hours are shown, with their son, kneeling before their manuscript and gazing up to Heaven to see the Coronation of the Virgin revealed to them in the sky surrounded by saints. This is an idealised portrait in the late style of the Bedford Master, *c.*1440.

 pastor eterne odemos
o bone cultos qui diu
deuoti gregis preces
attendens uoce lapla

de celo preculi sanctissimo dignu e
pilcopatu nycholau ostendisti tuu ta
multu

40 An unfinished fifteenth-century Book of Hours. The script was written first, and spaces roughed out for miniatures and illuminated borders which have so far been left completely blank.

nised that the decoration has to be added subsequent to the writing of the text (it would be exceedingly difficult the other way around). Therefore the script is supplied first, and blank spaces are left for the decoration. This presupposes very careful planning by the scribe even before he puts pen to parchment. Some manuscripts survive unfinished and show exactly this: the script in irregular blocks with blank spaces parcelled out for the insertion of pictures or initials. Often even completed manuscripts reveal traces of plummet lines marking off compartments which were subsequently filled with ornament. This may seem self-evident, perhaps, but it emphasises the important fact that decisions on the hierarchy of decoration, on the size and extent of the miniatures, on the richness and scale of the whole book were all settled and irrevocable long before the illuminator was sub-contracted into the operation. It is too easy to consider a famous illuminated Book of Hours as represent-

ing the design genius and initiative of an artist, or to try to link the subject-matter of the pictures with the personality of the artist. We easily classify manuscripts as being from the workshop of the Boucicaut Master, for example, or from the circle of Jean Pucelle, or from the shop of the Master of Petrarch's Triumphs. It was completely the other way round. Illumination in commercially-made manuscripts would undoubtedly have been discussed initially between the patron and the scribe (or the scribe's agent), but by the time that the written gatherings were sent off to the illuminator there was no longer any scope for innovation.

As they wrote out manuscripts, scribes sometimes went further than simply leaving spaces. Guide-letters were written in tiny script for the initials, and perhaps initials themselves were lightly sketched if the shape was unusual like a long 'V' tapering into the text. Written orders for subjects for pictures were sometimes added in microscopic script in the margins.

These may be very brief instructions, 'Job assis et tout nu', 'une bataille cruelle', or may actually describe the scenes in some detail. Iconography and symbolism were important in medieval art, and attributes of individual figures might need explaining fully if the artist did not have the exemplar in front of him or if the new manuscript was to be richer than its predecessor or somehow different in design. Marginal instructions are more common in literary or historical texts than in Books of Hours where subject matter was fairly standard: the Annunciation at Matins, the Visitation at Lauds, the Nativity at Prime, and so on. Even in Books of Hours the odd guide word can be detected and written directions necessarily imply that the artist could read. Sometimes in manuscripts one sees little marginal sketches beside the miniatures with thumb-nail diagrams of the scenes. These may have been drawn by the scribe or stationer, or by the master artist outlining plans in conversation with an apprentice, or even by the artist himself thinking aloud while doodling with his plummet. It was obviously intended that marginal instructions and sketches should be erased when the finished manuscript was tidied up for binding, and they survive only by chance. Cleaning is often itemised in medieval accounts for bookbinding.

The technique of illuminating a manuscript is described frequently in medieval artists' manuals. Actually painting in accordance with such written recipes is difficult and a certain care is needed in interpreting texts which may after all be literary exercises. Technique was presumably usually taught by practical example of master to apprentice or father to son rather than through written textbooks of self-improvement. Nonetheless, examination of unfinished manuscripts and an awareness of how manual writers claimed to operate can give us a reasonable insight into the stages of work.

Let us assume, as manual writers do, that the artist and scribe were different people, and that the written gatherings had been delivered with spaces marked out for initials and illuminated miniatures. Probably the surface of the parchment would need to be given a final rubbing over with pumice or a concoction of powdered

41 A page from a fifteenth-century English pattern book, with a sample alphabet with two forms of each letter. A scribe could either use these as models to copy or, more likely, to show to a client so that he or she could select a script of their choice.

cus madmton
um meum m
tende Domine

42 *Left* Partly unfinished fifteenth-century French Book of Hours showing the quick sketchy outlining in ink over the preliminary plummet underdrawing for the main initial and the miniature of the Birth of Christ.

43 *Above* Engraved playing cards seem to have provided models for illuminators especially in the Netherlands and the Rhineland towards the middle of the fifteenth century. Versions of the herons shown here in the three of birds occur in the borders of a number of manuscripts and early printed books.

glass mixed in bread, and perhaps dusted off again with some kind of chalk to give it a really clean grease-free surface. The very rough design can be sketched out in the appropriate place in metalpoint and sometimes altered and corrected to achieve an acceptable composition for a miniature or a good flowing curve for an ivyleaf border or a balanced geometric interlace. If a circle is part of the composition, one will expect to be able to detect the prick of a compass point showing through on the verso of the page. This sketch is very light. If done with charcoal or graphite it runs the risk of rough granules showing through into the final painting. The outlines are then quickly completed in ink, 'crisping up' the composition, as Cennino's *Libro dell'Arte* says in the late fourteenth century. The Göttingen Model Book of *c.*1455 recommends that these outlines over metalpoint should be done in very thin ink or thin black colour, and that they should then be polished with a tooth to make them receptive to paint on top. It is actually quite surprising how crude these preliminary outlines can be in an illumination which will end up as high quality work.

The actual designs of medieval miniatures were often copied from other sources. The details of exactly how this happened are elusive. The practice of taking an adaptable image in one manuscript and copying it into another goes back to the beginning of medieval book production. There is, for example, the frontispiece of the Codex Amiatinus, the great Bible copied out in Northumberland around 700 AD, showing the Old Testament prophet Ezra writing beside an open book cupboard. The picture is almost certainly copied from one in a sixth-century Italian manuscript when the same scene with the same book cupboard represented Cassiodorus rather than Ezra. An attractive picture seemed worth copying, even if it represented a different subject. At the other end of the Middle Ages, the miniature of the Christ Child being brought to Simeon in the *Très Riches Heures* of the Duc de Berry, illuminated by the Limbourg brothers in France between about 1411 and 1416, is very closely copied, including elaborate architectural details, from part of the fresco by Taddeo Gaddi painted in Florence in 1328 illustrating the Virgin Mary as a young child being brought to the Temple. The remarkable representation of one scene has been taken out of context and transferred into a manuscript. Obviously the Limbourgs did not sit down with the half-made *Très Riches Heures* and a set of paint pots in the chapel itself in Santa Croce in Florence but based their composition on a drawing or pattern sheet.

Pattern books played an important part in producing the images in manuscripts. Several dozen medieval pattern books and model sheets survive, some comprising myriads of isolated pictures which could be copied into part of manuscript compositions or into any other form of pictorial art, and others which are specifically for manuscripts with samples of decorated initials or borders. The most common pictorial images from patterns are birds and animals. Figures of deer, lions, unicorns and herons, for example, recur almost identically incorporated into borders and miniatures of widely divergent manuscripts. By the middle of the fifteenth century patterns were being engraved, or engravings were used as pattern sheets (this is not as clear as one would like), and images such as big roses and wildmen and a stag scratching its ear can be plotted in manuscript designs right across northern Europe. Certain workshops evidently had their own patterns. There are compositions that are characteristic of individual artists and their workshops, especially in Paris from as early as about 1220. There was a lawsuit in 1398 in which the well-known illuminator Jacquemart de Hesdin was alleged to have led a robbery against the painter John of Holland and broken open his strong-box and stolen various paints and patterns. In Flemish manuscripts of around 1500 one finds the most uncanny duplication of miniatures from one manuscript to the next, with every detail mirrored. Books of Hours illuminated by Simon Bening or Gerard Horenbout in Bruges in the early sixteenth century can look so alike that it can be very difficult to distinguish between them.

Not enough is known about how this copying was done, and nothing about why it was done. One would have imagined that a competent miniaturist would have been capable of

44 After the writing and the sketched outlines for the initial and borders, the next stage is the application of gesso and of gold leaf, seen here in an unfinished early fifteenth-century English manuscript of St Bernard.

45 A pattern-sheet for use in designing an illustrated border for a manuscript probably in early sixteenth-century Bruges. The vignettes show scenes from the story of David and Goliath, subjects sometimes chosen to decorate the opening page of the Penitential Psalms in a Book of Hours.

46 An opening from a partially-completed French Book of Hours. The border on the left is finished, but that on the right shows the preliminary plummet sketch and the crisping up in ink before the application of colour.

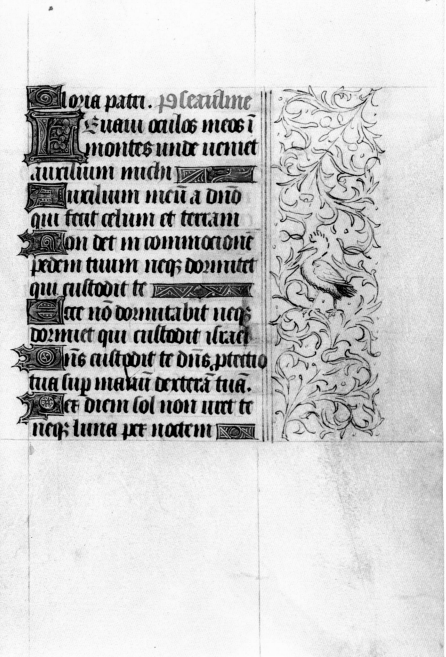

Gloria patri. et secula me

Levaui oculos meos i
montes unde ueniet
auxilium mich

Auxilium meu a dño
qui fecit celium et terram

Non det in commotione
pedem tuum neqz dozmitet
qui custodit te

Ecce no dozmitabit neqz
dozmiet qui custodit israel

Dñs custodit te dñs, ptectio
tua sup manum dexteram tua.

Per diem sol non uret te
neqz luna per noctem

47 An illuminated initial signed in the scrollwork by the illuminator Jacopo da Balsemo (*c.*1425–*c.*1503) of Bergamo. Signed manuscript illumination is very uncommon, though both examples illustrated here are from the Italian Renaissance when recognition of individual artistic talent became more accepted.

48 *Below* An illuminated border signed by Ambrogio da Marliano, illuminator to the Sforza court in Milan in the 1460s and 70s.

designing freehand. Yet there is good evidence that compositions of miniatures could be literally traced from one copy to another using transparent *carta lustra* or *carta lucida*, or could be duplicated by 'pouncing' in which the outlines of the original were pricked with rows of holes and placed over the new page and dabbed with a bag of colour, such as charcoal dust, to produce a dotted outline. This would provide a sketchy outline, like the metalpoint drawings described above, ready to be strengthened in ink in preparation for colouring.

Some pictures or initials in medieval manuscripts are formed only of drawing, especially in the Carolingian and Romanesque periods or in some scientific or practical books, but most decoration was intended to be coloured and it was often illuminated. Strictly speaking, an 'illuminated' manuscript contains gold or silver which reflects the light. A manuscript with much decoration but in colours without actually having gold or silver is, technically, not illuminated. Members of the Cistercian Order were permitted to ornament their manuscripts but not to illuminate them as gold was thought to be frivolous and inappropriate to an austere way of life. Illumination with gold goes back into antiquity but is especially common in the later Middle Ages. Manuscripts such as Books of Hours are almost always illuminated. If gold leaf is to be applied to a design in a manuscript it is put on before the colour. This is crucial for two reasons. The first is that gold will adhere to any pigment which has already been laid, ruining the design, and secondly the action of burnishing it is vigorous and runs the risk of smudging any painting already around it.

There are several methods of applying gold to manuscript pages and sometimes more than one technique was used in a single miniature in order to achieve different effects. There are three basic types of application appropriate for books. Two methods use gold leaf, and one uses powdered gold. In the first a design is brushed on in some kind of wet glue and the gold leaf is laid on top and is burnished when it is dry. This is used particularly in very early manuscripts and it can achieve wonderful areas of shimmering gold like the backgrounds of early panel paintings. In the second method a sticky gesso is prepared and built up so that the design is really three-dimensional. When the gold has been applied and polished with a burnishing tool it looks extremely thick and the curving edges of the design catch the light from many angles at once. This is the most wonderful medieval gold in manuscripts and is discussed in more detail below. The third method is to apply what is called 'shell' gold, a powdered gold mixed with gum arabic into a kind of gold ink (and commonly dispensed from a sea shell like a mussel or oyster, hence the name) and applied with pen or brush. It can also be called matt or liquid gold. Unlike leaf gold, it was added after the colour. It was particularly used from the second half of the fifteenth century, and can resemble the frosted gold printed now on some Christmas cards. It is curious that it was so popular, because the effect (at least to modern eyes) can easily be sugary and overdone, it must have been more expensive to make since grinding up pieces of gold uses more of the material than laying leaf, and those who have tried highlighting in shell gold over pigment report that it is a slow process to apply scores of hatched lines with repeated precision.

Gold leaf is not especially easy to use either. It is a property of gold that, unlike many other metals, it can be hammered thinner and thinner without ever crumbling away. A piece of gold leaf is infinitely thinner than the thinnest paper.

50 Two types of gold appear on this miniature of St Stephen from a choirbook illuminated in Prague about 1405. The background of frenzied cockatrices behind the saint is painted with liquid or 'shell' gold, applied probably with a pen. But the halo and the surround are of burnished gold, applied as leaf laid over raised gesso. This has been not only burnished to a high finish but also stamped on top with delicate patterns.

It is virtually without thickness and has almost no weight. If rubbed between the finger and thumb it will fade into nothing. If dropped it hardly seems to flutter downwards. If it settles on a hard surface ruffled or folded it can be straightened out with a puff of breath, unwrinkling itself instantly like a shimmering shaken blanket. It can be eaten and seems to vanish on the tongue. Cennino recounts that goldbeaters could make 145 leaves of gold from hammering one ducat. It was comparatively rarely used in medieval manuscripts before about 1200, with certain fantastically lavish and princely exceptions. This may be in part because until then many manuscript painters worked in monastic cloisters open to the wind. Trying to handle gold leaf in such conditions must have been fraught with frustration and wasted gold. But by the thirteenth century, when most work was

probably done indoors, the manipulation of gold leaf was at least reasonably possible. Gold leaf is comparatively cheap, even now. Thus in Robert Brekeling's contract to make a manuscript in 1346 with gold initials throughout, the gold was accounted at 18d., less than a tenth of the overall cost. Cennino says that when buying gold leaf, 'get it from someone who is a good goldbeater; and examine the gold; and if you find it rippling and matt, like goat parchment, then consider it good'.

Both Cennino and the Göttingen Model Book describe at some length the mixing of gesso for raised illumination. Begin with slaked plaster of Paris, and grind in a little white lead (less than a third of the amount of the plaster, Cennino says). The mixture is very white and crumbly. The Göttingen manuscript takes up the recipe: 'then fetch *bolum armenum* at the

51 The Göttingen Model Book of the mid-fifteenth century provides detailed instruction on the different stages of painting the curling coloured acanthus leaves which occur in the borders of so many illuminated manuscripts.

apothecary's, and grind so much into it that the chalk will turn a red flesh colour therefrom'. Armenian bole, as it was called although it certainly came from many places closer than Armenia, is a kind of greasy red clay. It has no real function in gesso except to supply colour. When the gesso is eventually applied to the white page the inclusion of a colouring substance will make the mixture easier to see; and if the gold should ever wear off a bit, a pinky brown colour underneath gives a more pleasing and warmer glow than stark white. It is interesting to look out for traces of bole having been used in the illumination of manuscripts. Usually, especially in rather battered manuscripts, one can detect whether or not bole has been mixed with the gesso under the gold. In Italy it is pink. In Flanders and Germany it is brown. In Paris it is usually not used at all. This must be one of those curious differences which, if enough examples could be systematically collected up and documented, might one day help localise manuscripts or at least the place of the illuminator's training.

However, to return to the recipe, we now have plaster and white lead, with or without colouring. Add a dash or two of sugar. Sugar, or honey for that matter, has the property of attracting moisture and it is important that the concoction should remain damp as long as possible. The mixture is now powdery, pink, sweet, and poisonous. It is sensible to add a little gum, though the recipes do not call for it. The substance can be dried into little pink pellets and stored like this. When it is needed mix it up with a little clear water and egg glair, presumably on a slab of stone, crunching the mixture over and over with a palette knife until it is really smooth and runny, without bubbles. The egg glair is made from the sticky liquid which forms at the bottom of a bowl of whipped egg whites, especially if a cup of cold water is tipped in too.

This is gesso, a mixture which needs to be stirred often, ready for use. It is applied with a quill pen, not a brush. Speed is important, as is a lightness of touch so as not to scratch the parchment with the nib. The liquid is puddled into the centre of the piece to be gilded and then quite quickly drawn out carefully into the

corners and over the parts of the manuscript page marked out by the underdrawing, round the shape of initials, into ivyleaves, haloes, dotted across tessellated chessboard backgrounds, and so on. When finished, the page looks as though it is covered with pink boils, blobby and thick. Presumably the medieval illuminator, unlike the scribe, worked at a flat table rather than at a sloping desk as the gesso is piled up thickly and held by surface tension and would run down a slope. It takes some time to dry. It is tempting to try to lay the gold too soon but this will only cause smudging.

Return next day. The gesso may have formed hollows in the middle as it dried, and if so it can be scraped smooth again with a knife. Damp weather, or dank early mornings are said to be good for applying gold leaf. A fluttering piece of gold leaf is picked up on a thin flat brush called a gilder's tip and can be allowed to fall onto the soft gilder's cushion where it can (if appropriate) be blown out flat and cut with a sharp knife into strips or other simple shapes before being picked up again on the brush. The illuminator breathes heavily onto the manuscript page and the dampness of his breath makes the gesso slightly tacky again, and the gold leaf can be lowered into place, overlapping the edges of the gesso pattern. As it nears the page the gold leaf seems to jump into place. It is covered quickly with a piece of silk and pushed quite firmly with the thumb. Patterns will be impressed from the weave of the silk but they are of no consequence as they will be smoothed away in a moment. The illuminator then takes up the burnishing tool; this was traditionally a 52 dog's tooth mounted on a handle, but Cennino says that the tooth of a lion, wolf, cat, or any carnivore is as good, and he goes on to describe how to make a stone burnishing tool from a piece of hematite. The tool is rubbed up and down over and around the gold and into the crevices at its edge. As it rubs, the gold which generously overlapped the edges of the gesso design will fall away and these infinitely small crumbs of gold dust can be brushed off or swept up. If a page of a medieval illuminated manuscript is tipped to reflect light off the surface one can often see the marks of where the burnisher

52 A modern burnishing tool with a handle, similar to the tools used in medieval times to polish gold once it had been applied to the page.

has overshot the design and pushed into the vellum. Obviously it was rubbed with pressure and speed. It is almost miraculous the way that a microscopically thin piece of gold will buff up into a really remarkable shine, even as one watches. The transformation is startling. It will never fade. Gold cannot tarnish. The burnished gold in manuscripts sparkles as new after five hundred or a thousand years.

Once the gold is in place, the rest of the decoration can be coloured. A number of twelfth-century English manuscripts evidently had the underdrawing marked out with tiny letters of the alphabet, 'a', 'r', 'v', and so on, to indicate the colours, *azure, rouge, vert* (unless it is Latin, *azura, rubeus, viridus*), as if the infilling was more-or-less painting by numbers. Quite often one has to assume that the underdrawing is by one artist and the colouring by another. The elaborate and to us rather patronising instructions on how to lay colours given in the Göttingen Model Book suggest that the completion of simple designs was a beginner's task. Paint the red. Then take a brush and outline it with darker red. Then dilute the dark red in a shell and lighten the red. Then take white and heighten the light red. These kind of directions for painting simple leaves run for many pages, colour after colour in the same order, as if addressing a child. A twelfth-century miniature in Prague does indeed show a child Everwinus painting manuscript ornaments while his master, the scribe Hildebertus, shouts at a mouse stealing cheese. This is not to belittle the works of medieval manuscript painters by suggesting that all manuscripts were painted by children: far from it, for there are illuminated manuscripts by artists of the highest rank, including Perugino, Fouquet, Botticelli, Mantegna, Dürer, Holbein.

It is perhaps possible that the Göttingen Model Book instructions were not for any practical use at all but simply show (in the literary disguise of a primer) a scholar's analysis of how he believed decoration in a manuscript could have been executed. We too can gaze at manuscripts and detect simple sequences of applying the colour, one layer overlapping another. First the area is painted, then darkened for the shadows, and then lightened on the other

53 A twelfth-century apprentice Everwinus sits practising flourished decoration while his master Hildebertus turns from his beautifully-appointed workdesk to curse and shout at a mouse running off with his cheese.

side, and then finished with any delicate details of facial expression in dark colour and finally in white. Once again, unfinished manuscripts can show different stages. There is no especial trick to the technique of manuscript painting. It was executed much as anyone now would if attempting the same task. Genius stands out, and hack work can be very bad indeed.

Some modern scribes assert with the credibility of practical experience that a great deal of medieval manuscript decoration was executed with a pen rather than a brush. This may have been true, especially for flourished initials (for example) where the body of the infilling was in one colour without heightening. If the paint has rubbed thin, one can see penstrokes. The 51 Göttingen instructions suggest both implements were used: 'you shall apply all colours, shade and heighten them, with a brush, except in the checkered backgrounds, which you shall apply with the pen and heighten with the brush; otherwise, all foliage and flower work with a brush, large or small'. There are sixteenth-century instructions for making brushes for portrait miniatures. Use clippings from the tail hairs of the miniver or the calaber (species of ermine and squirrel respectively) rolled up in strips of paper, tied, and inserted into the end of a barrel of a feather. Thus it may be that pictures of illuminators apparently holding quills are in fact wielding brushes.

The range of colours available to the medieval manuscript painter was surprisingly large. Red, for example, could be natural cinnabar — mercuric sulphide, found since classical times in Spain and at Monte Amiata, near Siena, and elsewhere. Vermillion is similar in chemical composition, and was made from heating mercury with sulphur and then by collecting and grinding the deposits of vapour formed during the heating process. It is very poisonous, and so the old artist's trick of bringing a brush to a fine point by licking it was a calculated risk. Alternatively, red pigment can be made from plant extracts. Brazilwood has already been mentioned in connection with red ink. Madder, a rather purply red, is made from the root of the madder plant, which grows wild in Italy. A romantically named red, widely used in book

decoration, was dragonsblood, described in medieval encyclopedias as a pigment formed not merely from dragons but from the mingling of the blood of elephants and dragons which have killed each other in battle. Botanists assert that it comes from the sap of the shrub *Pterocarpus draco*.

Blue is the second most common colour in medieval manuscripts, after red. Probably its most common colour source was azurite, a blue stone rich in copper, found in many countries of Europe. It is very hard, and has to be smashed and then rammed and ground patiently with mortar and pestle until it slowly and dustily turns to powder. Another blue, much more of a violet blue, was made from the seeds of the plant turnsole, now called *Crozophora*. But the blue prized above all others was ultramarine, blue from far beyond the sea, made from lapis lazuli, found naturally only in the region of Afghanistan. The journey that this stone must have taken to reach Europe is almost unimaginable, for it was available long before the time of Marco Polo, and it must have passed in bags from one camel train to another, to carts, and ships, a medium of commerce over and over again, before finally being purchased at enormous expense from the apothecaries of northern 54 Europe. Good blue paint was valuable. In the twelfth-century Winchester Psalter it was scraped off for re-use. The inventory of the Duc de Berry, drawn up in 1401–3, includes among his treasures of unbelievable wealth two precious pots containing ultramarine.

Other pigments included green from malachite or from verdigris, yellow from volcanic earth or from saffron, white from white lead, and so on. There were several techniques of mixing pigments into paints. Both white of egg (egg glair) and yellow of egg (egg tempera) were common, egg being a very effective glue. Gums too were made from fish lime (the best was from the air bladder of the sturgeon) or from animal size made usually by boiling up pieces of skin. The grinding and the mixing and the tempering of paints were essential prerequisites to the decorating of illuminated manuscripts.

Presumably early medieval illuminators sat in the cloister like everyone else engaged in book

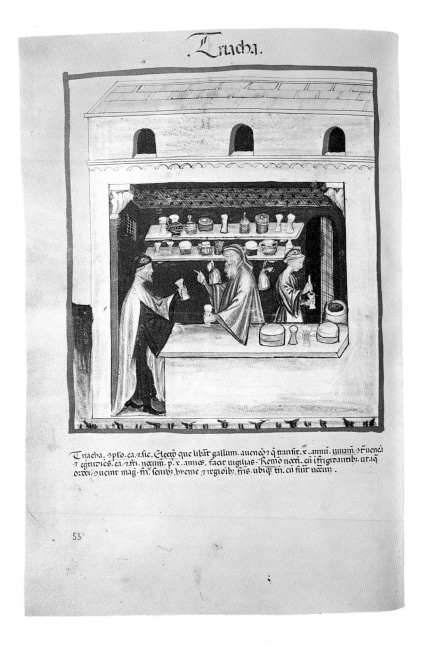

. Triacha .

Triacba. opto. ca. ɪ. ſic. Electo que libāt gallum. auencō ꝗ trāſir. c̄ .annı. ṽmam. ꝯ Fuencā ꝗ egitiuoieſ. ea. ɪ. frī. nocum. p. x. annoſ. facit uigilias.—Remo nocti. cũ ifrigiꝺantibꝪ. ut aꝗ ortcȶ̌ꝺ uentr mag. frī. ſenibꝪ. breme ꝗ regioibꝪ. friſ. ubiꝗ̌ tñ. cũ ſuit nocũ .

53ᵛ

54 An apothecary's shop, shown in an early fifteenth-century Italian manuscript. The ingredients used by illuminators could be bought from such suppliers.

work. The self-portrait of Hugo Pictor, the late eleventh-century Norman painter, *'imago pictoris & illuminatoris huius operis'*, in a manuscript in the Bodleian Library, shows a tonsured monk sitting in an armchair under an open architectural arch. His manuscript is to his right. Hugo holds the page down with a knife in his right hand and with his left hand he dips a curved quill-like implement – it may still be a brush – into a horn in the arm of his chair. (He presumably painted with his left hand, or drew his own picture in reflection.) From over 400 years later, at the other end of our story, are two self-portraits by the renowned sixteenth-century Bruges illuminator Simon Bening (1483–1561). He was no monk; he married twice and had five legitimate children as well as an illegitimate daughter. In his portrait he is working indoors by the lattice window of a town house. The window is to the left of his desk, presumably so that light falling on his hand will not hide the detailed work in shadow. He holds his glasses (pictures of painters with spectacles are found as early as the fourteenth century) and wears a high smock, his hair held by a kind of black skull cap. The slightly later English miniaturist Nicholas Hilliard recommended the wearing of silk clothes while working, lest dust or hairs fall on the delicate wet paint, and keeping the head still for fear of falling 'dandrawe of the head'. Shells of colours are ranged with other implements to the left of Bening's desk, next to the window.

Most medieval professional illuminators charged by the work, rather than by the hour. Generally labour was cheap and materials were expensive. Some of the earliest illuminated books from secular workshops, grand Bibles and luxury books made in and around Paris in the second half of the twelfth century, show one of a series of little marks in plummet beside each illuminated initial: one stroke, three strokes, a cross, and so on. These seem to be related to the number of initials in each gathering, and are a calculation for payment. Illuminators' accounts were usually based on the number and size of the decorations and multiplied out. A thirteenth-century English glossed Gospel Book, for example, was supplied with red and blue

qui peccaui ei. donec iudicet causam mea. & auferat iudiciū meū. & educit
in luce. & rursū. Benedicā te dñe qm iratus es m. auertisti faciē tuā a me. &
miser tus es mei. Dñs quoq; loquitur ad peccatores. Cū ira furoris mei fuerit.
rursum sanabo. & hoc est qd in alio loco dicitur. Quā magna multitudo boni ta
tis tue dñe. quā abscondisti timentib; te. Que oia replicat. affirmare cupientes
post cruciatus atq; tormenta futura refrigeria. que nunc abscondita sunt ab iis
quib; timor utilis est. ut dū supplicia reformidant. peccare
desistant. & nos dī solius debemus scientie derelin
quere. cui non solū misedie. sed & tormenta
in pondere sunt. & nouit quē quo modo.
aut quamdiu debeat iudicare.

Soluiq; dicamus. qd humane conuenit fragilitati. Dñe ne in furore tuo
arguas me. neq; in ira tua corripias me. Et sicut diaboli & omnium negatorū
atq; impiorū qui dixerunt in corde suo non est ds.
credimus eterna tormenta. sic pec
catorū atq; impiorū & tamen
xpianorū quorū opa
igne pbanda
sunt atq;
purganda. moderata
arbitramur. & mixta clementie
sententia iudicis.

EXPLICIT LIBER BEATI
IHERONIMI SUP YSAIAM

56 Simon Bening (1483–1561) of Bruges, a self-portrait dated 1558 of one of the last and most highly regarded manuscript illuminators. He has been working under magnification with the window to his left presumably so that the shadow of his own hand will not fall across the delicate work.

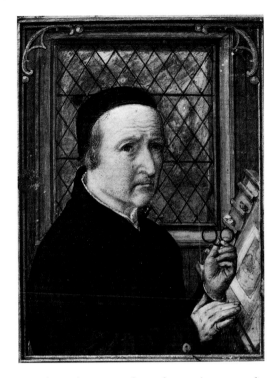

55 *Opposite* Hugo Pictor, a tiny self-portrait of a Norman (or possibly Anglo-Norman) scribe and illuminator of the late eleventh century.

initials and paragraph-marks at the cost of a penny for 300. There are, it seems, 7996 in the volume but the decorator gave a slight discount and charged 26d. One fifteenth-century English miscellany has three sizes of initial: big gold initials were charged at 4d. each; large painted initials were three for a penny; smaller paragraph marks were ten for a penny. In the Paston Letters there is an account for a Psalter decorated by Thomas Lympnour of Bury St Edmunds in 1467: full-page illuminations were 12d. each, half-page illuminations were 4d. each, small painted initials were 4d. a hundred, and capital letters were a penny a hundred. Here too is an exact sense of the hierarchy of decoration. The illumination alone came to £1.5.10d.

The same book cost 12 shillings for binding. Seventy-five years earlier, Robert *bukebinder* charged York Minster 10 shillings for binding a Gradual for the choir, plus 20d. for four skins of parchment for flyleaves and 3s.2d. for a deerskin to cover the whole book. It was rather bigger than the Pastons' book, and so the price is

comparable. But the thirteenth-century glossed manuscript, just cited, was not bound at all but sewn into wrappers, which cost a penny for sewing and a halfpenny for parchment. This was much cheaper.

The history of bookbinding is a long and intriguing subject, and in its own right could well merit a monograph in the present series of books on medieval craftsmen. It is the last stage in producing a manuscript, however, and so must be touched on here. A book was not yet ready for the customer when the artist had completed the illumination. It was still in loose gatherings and perhaps even dismembered further into separate pairs of leaves. These all had to be collected up, reassembled into order, and held together in some serviceable binding. In the late Middle Ages this would be the task of the stationer or bookseller and when a commercial bookbinder can be identified by name, he often proves to have been a stationer. This was the person who had taken the order for the manuscript in the first place and who had distributed the gatherings among the illuminators of the town. It was now the stationer's task to call in the various parts of the book, clean them up (erasing guidewords and smudges left over from the various stages of manufacture), assemble them in sequence according to the signatures or catchwords, and to bind the book for the client. In the earlier Middle Ages, when books were mostly made by monks, the binding was carried out by whatever member of the community was able to do so. The Lindisfarne Gospels, according to a tenth-century inscription, had been bound by Bishop Ethelwald, 'as he well knew how to do'. Another bishop, St Osmund of Salisbury (d.1099), is credited by William of Malmesbury with having bound manuscripts for the cathedral with his own hands. Quite often catalogues of monastic libraries include a shelf or two of unbound books, sometimes described as *'in quaternis'*, which presumably means stitched into some kind of wrappers rather than literally in loose quires.

From the earliest times when manuscripts were first made in book form, rather than as rolls or tablets, the gatherings were held together by

sewing thread through the central fold. The earliest surviving Coptic bookbindings date from around the fourth century. They are held together by chain stitching, that is, with each gathering sewn through the centre and then linked around its spine to the next gathering which is stitched too and linked in sequence to the next, and so on. The book is a stack of gatherings joined one to another with the sewing of the first and last gatherings knotted into the covers. Greek and Oriental bindings were basically like this, and so were the earliest monastic bindings of western Europe. Ethiopian bindings still are, and a good shelf of modern Ethiopian books looks much as the library of Jarrow must have looked in the eighth century with big square wobbly wooden bindings.

Through most of the Middle Ages, however, manuscripts were sewn onto bands or thongs or cords running at right angles horizontally across the spine. The stitching of each gathering goes through the centre fold and around the band, through the centre fold again and out around the next band, back through the centre fold again, and so on. The next gathering is the same, and the next, and the next, until all the gatherings are attached securely to the thongs across their spines. From at least the twelfth century the stitching was done with the help of a sewing frame. This is a wooden contraption, rather like a gate, which stands upright on the bench. The bands for the spine are tied to it vertically, suspended from top and bottom of the frame. The first gathering of the manuscript is placed on the bench with its spine up against these taut bands and is sewn through its centre and around the bands. Then the next gathering is placed on top, tapped down with a block of wood to keep the result firm and tight, and sewn too and around the bands, and so on, one after the other, until all the book is there lashed by its spine to the frame. Sewing is the most time-consuming part of bookbinding. Methods of actually stitching the gatherings varied from century to century and place to place, sometimes a herring-bone stitch, sometimes a kettle stitch, sometimes going round the band once, or twice round it, or through splits in the bands themselves, and other variants interesting for

57 A thirteenth-century bookbinding from Fountains Abbey in Yorkshire. Its wooden boards are covered with plain whittawed leather and were once fitted with metal bosses in the corners.

58 A tiny Romanesque stamp of King David playing a harp. This may have been a bookbinder's tool, and impressions of similar tools of the same subject occur on a number of twelfth-century French decorated bookbindings.

their own sake and for dating bindings but not altering the basic principle. When the sewing is complete, the bands can be untied from each end of the frame. The book may feel loose and swivel rather, and this can be tightened up (as it was in the later Middle Ages) by sewing on stout headbands along the top and bottom edge of the spine.

The boards of medieval manuscripts were generally made of wood. Oak was commonly used in England and France; beech was usual in Italy, or pine, and bound Italian manuscripts feel lighter than northern books. Occasionally the boards were made of leather. The use of pasteboards (a kind of cardboard formed of layers of waste paper or parchment glued together), can be followed infrequently through the Middle Ages and from the late fourteenth century became more and more common in southern Europe, in Spain and into Italy in Bologna, Milan, and later Padua. The boards, of whatever material, were squared up into the shape of the book. In earlier manuscripts the boards were cut flush with the edges of the pages; after about 1200 they began to project beyond the edges and were often bevelled on their edges. The bands on the back of the sewn gatherings were threaded into the boards. Frequently some kinds of flyleaves were added at each end of the book (these explain the cost of extra vellum in bookbinders' bills), sometimes re-using waste leaves of old obsolete manuscripts. The bands can be attached into the boards by several methods, varying with time and place, but the basic method is the same. The ends of the bands were secured into the boards by hammering in wooden pegs or, sometimes in Italy, with nails. The manuscript is now within plain boards, and was usable left like this. The inventory made in 1481 of the private library of Jean Bayart, late Canon of Courtrai, included 120 books of which forty-six were simply *'in asseribus'*, in boards.

Usually, however, the outside of the book ₅₇ was covered with leather, tawed or tanned, and sometimes dyed. A few Carolingian bookbindings have simple stamped patterns on the ₅₈ leather. There was a fashion for stamped bindings in northern France in the later twelfth

century, and bindings ornamented with little tools exist (but are unusual) from the thirteenth and fourteenth century. Then around 1450 the practice became much more common. Sides of bindings from then on were frequently ornamented with repeated impressions of floral or animal devices. This is done with a metal tool on ₅₉ a wooden handle. The tool is heated. The binder grasps the handle in both hands and leans over the binding and pushes down, holding the handle close to his chest and chin, rocking slightly one way and then the other, and then lifts the tool quickly up. No great pressure is needed to leave a neat crisp blind impression. These were arranged in rows, or in lattice or other patterns. The outside of the binding was often fitted then with metal bosses or protective ₅₇ corner-pieces, and usually with some kind of clasp to hold the book shut. Folded parchment, however well creased, is springy and inclined to cockle in varying temperatures and humidities unless it is held securely shut by the gentle pressure of clasps.

Medieval books were sometimes enclosed further in loose jackets, called chemises, which wrap around the fore-edge and keep out the dust. Far more frequently than the surviving medieval bindings suggest, manuscripts may have been covered with textiles and brocades (which have mostly long-since perished) or with ₆₀ precious metals and jewels (which have mostly contents page been removed with motives of varying legitimacy) or with enamels or paintings. Medieval inventories often describe bindings, since the outside of a book is a simple guide to its recognition, and give the impression that the private libraries of rich men or the treasuries of great churches were filled with multicoloured and elaborate and precious bindings. The craftsmanship of such bindings takes us beyond the work of the stationer and into the shops of the jeweller or enameller. It is always worth glancing at the fore-edge of a medieval manuscript. Usually the edges have been planed off every time a book has been rebound, but the fore-edge is sometimes missed and it is occasionally possible to see traces of painted designs on the very edges of the leaves. Even if the binding itself is much later, one can sometimes dimly

59 The upper cover of a manuscript brought from Paris to Durham Cathedral by Robert of Adington in the late twelfth century. The original tanned leather has been laid down onto a later binding, and shows contemporary decoration formed of multiple impressions of tiny pictorial and ornamental stamps.

60 Medieval bookbindings made of textile and embroidery were evidently once very common, but they are so fragile that extremely few survive. The example here covers a Flemish Book of Hours of the early fifteenth century.

61 *Overleaf* Hereford Cathedral Library. In the late Middle Ages and even until the seventeenth and early eighteenth century, the books of some institutional libraries were chained to their shelves. The best preserved chained library in Britain is this at Hereford.

make out a shadow of what was evidently once a polychrome book, decorated on every side. The outsides of medieval manuscripts have changed, probably, much more than their insides.

This story has taken us from the cows and sheep in the meadows, from which the parchmenter worked, through the whole business of scribes ruling and quill-cutting and copying. It has seen ingredients from trees and shrubs, insects, birds, animals, and mountainsides all over Europe and imported along the trade routes from far beyond Europe. It has taken in the transcription and the preservation of all ancient and medieval learning and literature by churchmen and laity. It has looked at the craft of the illuminator as it was among most of our ancestors for a thousand years. And it has ended up again with the cows and sheep whose skins the bookbinder used to cover medieval manuscripts which still exist in hundreds of thousands.

GLOSSARY

Bifolium Two leaves (four pages) formed of a single folded sheet of vellum or paper.

Book of Hours A lay person's prayerbook containing prayers and psalms to be said at different times of the day.

Burnishing tool Tool used to polish gold once it has been applied to the manuscript page.

Catchword Words written by the scribe in the lower margin of the last page of a gathering repeating those at the top of the next page, as an aid to the binder to keep the gatherings in order.

Codex Manuscript volume.

Egg glair White of an egg used as an adhesive in mixing pigments into paints.

Egg tempera A paint which uses egg as an adhesive.

Gathering Folded section of vellum or paper leaves which could be bound together with other gatherings to form a book.

Gesso Plaster-like ground used for raised illumination.

Gloss Commentary or interpretation or quotation from a recognised authority added in the margins of a manuscript or between the lines of text.

Lunellum Crescent-shaped knife for scraping skin during the preparation of parchment.

Plummet A piece of lead used for ruling a parchment page.

Pouncing Duplication of pictures by pricking holes around their outlines and then rubbing pounce over them to reproduce a dotted outline on a sheet beneath.

Quire Gathering (q.v.).

Scriptorium Room set apart for writing, especially in a monastery.

'Shell' gold Powdered gold mixed with gum arabic into a kind of gold ink, and applied with a pen or brush.

Signature Gathering (q.v.).

Watermark Distinguishing mark or design on paper, visible only when held up to the light, and made when the paper is in a pulp form.

FURTHER READING

B. BISCHOFF,
Latin Palaeography, Antiquity and the Middle Ages, trans. D.O. Cronin and D. Ganz, Cambridge, 1990.

C. F. BÜHLER,
The Fifteenth-Century Book: The Scribes, the Printers, the Decorators, Philadelphia, 1960.

CENNINO D'ANDREA CENNINI,
The Craftsman's Handbook, 'Il Libro dell' Arte', trans. D.V. Thompson, New Haven, 1933.

H. CHILD, ed.,
The Calligrapher's Handbook, London, 1985.

C. P. CHRISTIANSON,
A Directory of London Stationers and Book Artisans, 1300–1500, New York, 1990.

A. COHEN-MUSHLIN,
The Making of a Manuscript, The Worms Bible of 1148 (British Library, Harley 2803–2804), Wiesbaden, 1983 (Wolfenbütteler Forschungen 25).

L. M. J. DELAISSÉ,
'Towards a History of the Medieval Book', in *Codicologica*, I, *Théories et Principes*, ed. J.P. Gumbert and M.J.M. De Haan, Leiden, 1976, pp.27–39.

A. DEROLEZ,
Codicologie des Manuscrits en Ecriture Humanistique sur Parchemin, Brepols, 1984 (*Bibliologia, Elementa ad Librorum Studia Pertinentia*, 5–6).

M. DROGIN,
Medieval Calligraphy, Its History and Technique, Montclair and London, 1980.

J. D. FARQUHAR,
Creation and Imitation, The Work of a Fifteenth-Century Manuscript Illuminator, Fort Lauderdale, 1976.

L. GILISSEN,
Prolégomènes à la Codicologie, Ghent, 1977.

J. GLENISSON, ed.,
Le Livre au Moyen Age, Paris, 1988.

D. HUNTER,
Papermaking, The History and Technique of an Ancient Craft, 2nd edn, New York, 1947.

H. LEHMANN-HAUPT, *The Göttingen Model Book, A Facsimile Edition and Translations of a Fifteenth-Century Illuminators' Manual*, Columbia, 1972.

J. MURRELL,
The Way How to Lymne, Tudor Miniatures Observed, London, 1983.

R. REED,
Ancient Skins, Parchments and Leathers, London and New York, 1972.

D. V. THOMPSON,
The Materials and Techniques of Medieval Painting, New York, 1956.

W. WATTENBACH,
Das Schriftwesen im Mittelalter, 3rd edn, Leipzig, 1896.

PHOTOGRAPHIC CREDITS

Bibliothèque Nationale, Paris: 19 (MS lat. 1107, f.400), 28 (MS fr. 9198, f.19), 38 (MS lat. 9389, f.177); Bibliothèque Royale Albert 1er, Brussels: *front cover* (MSS 9278–80, f.10); The Bodleian Library, Oxford: 4 (MS Ashmole 1511, f.29v), 13 (MS Douce 180, p.92), 18 (MS Auct. D.I.13, f.1), 31 (MS e. Mus. 198*, f.8), 40 (MS Douce 267, f.162v–3), 44 (MS Laud. Misc. 322, f.53), 46 (MS Douce 267, f.35v–6), 55 (MS Bodley 717, f.287v), 57 (MS Lyell 8); University Library, Bologna: 3 (Cod. Bonon. 963, f.4); The British Library, London: *title page* (MS Royal 10.A.xiii, f.2v), 11 (Add MS 59678, f.328), 52; Trustees of the British Museum, London: 25 (MLA 1909, 6–7, 2), 43 (P&D H.Lehmann-Haupt, *Gutenberg and the Master of Playing Cards*, fig.24), 58 (MLA 65); The Dean and Chapter of Durham: 59 (MS A.III.17); University Library, Durham: 29 (MS Cosin V.III.1, f.22v); Ecole des Beaux Arts, Paris: 45 (M2235); Master and Fellows, Magdalene College, Cambridge: 41 (MS 2981); The Metropolitan Chapter Library, Prague: 53 (MS A XXI/1, f.153); Museum of London: 15 (No.15397); The Board of the Trustees of the National Museums and Galleries on Merseyside (Liverpool Museum): 39 and *back cover* (MS M12001, f.237v); The National Trust, Waddesdon Manor, Aylesbury: 22 (MS 20, f.13v); Niedersächsische Staats- und Universitätsbibliothek, Göttingen: 51 (MS Uffenb. 51, f.3v–4); Österreichische Nationalbibliothek, Vienna: 54 (Cod. ser. nov. 2644, f.53v); Peterhouse, Cambridge: 32 (MS 193); The Pierpont Morgan Library, New York: *contents page* (G.44, f.1v); Pitkin Pictorials Ltd, Andover: 61; Private Collection. Photo: Museum of London/Royal Academy: 16; Royal Library, Copenhagen: 8 (MS 4, f.183v); Courtesy of the John Rylands University Library of Manchester: 14 (Rylands Latin MS 11, f.14v); By permission of the Master and Fellows of St John's College, Cambridge: 1 (MS A.8, f.103v); Sotheby's: 2, 5, 6, 10, 12, 17, 20, 21, 24, 26, 27, 33, 34, 35, 36, 37, 42, 47, 48, 49, 50, 60; Staatsbibliothek, Bamberg: 7 (MS Patr. 5, f.1v); Staatsbibliothek Preussischer Kulturbesitz, Berlin. Photo: Bildarchiv Foto Marburg: 30 (MS lat. 2°, f.384v); Courtesy of the Board of Trustees of the V&A, London: 23 (MS A.L.1646–1901, f.15), (56 (P.159–1910); The Dean and Chapter of Westminster, London: 9 (MS 37, f.225).

ACKNOWLEDGEMENTS

Two occasions during the writing of this book provided exceptional opportunities for furtive and extensive note-taking, and I acknowledge both events unreservedly before all others. The first was a weekend symposium on the techniques of medieval manuscript making, organised by Christopher Clarkson and held at West Dean College in the spring of 1990. I am especially indebted to the demonstration there of parchment-making by Wim Visscher, Assistant Manager of William Cowley, Parchment Works, Newport Pagnell. It is Mr Visscher who is shown in Fig.5, in a photograph taken by David Dorning, from whom we received instruction in ink-making. The second great occasion for instruction was the conference of The Calligraphy Connection held at St John's University, Collegeville, Minnesota, in the summer of 1990. I asked endless questions from many of the hundreds of calligraphers present, and attended classes in practical pigment-making and gilding taught by Brody Neuenschwander, where we mixed gesso with gusto and laid gold leaf. I hope that I may have correctly followed my teachers. I have systematically pillaged from both sets of notes, and if I have misunderstood what I heard then the fault is mine, and if my recast lecture notes have any merit the full acknowledgement must go to Messrs Clarkson, Visscher, Dorning and Neuenschwander. I am the Everwinus of Fig.53, doodling inkily at the feet of the master.

Practical advice at all stages was given by Mette Tang Simpson. Individual questions were answered by Jeremy Griffiths, Mark Van Stone, Michael Gullick, Scott Schwartz and many others with whom I have discussed techniques. Photography at Sotheby's was done by Fraser Marr, with help from Deborah Phillips. Mr Martin Schöyen kindly lent items to be photographed. The photograph for Fig.42 was sent to me by M Pierre Berès. The oak galls shown in Fig.26 were gathered in the garden of my aunt Mrs Margaret Shortt.